creative *tangle*

*Creating Your Own Patterns
for Zen-Inspired Art*

Trish Reinhart

NORTH LIGHT BOOKS
CINCINNATI, OHIO
createmixedmedia.com

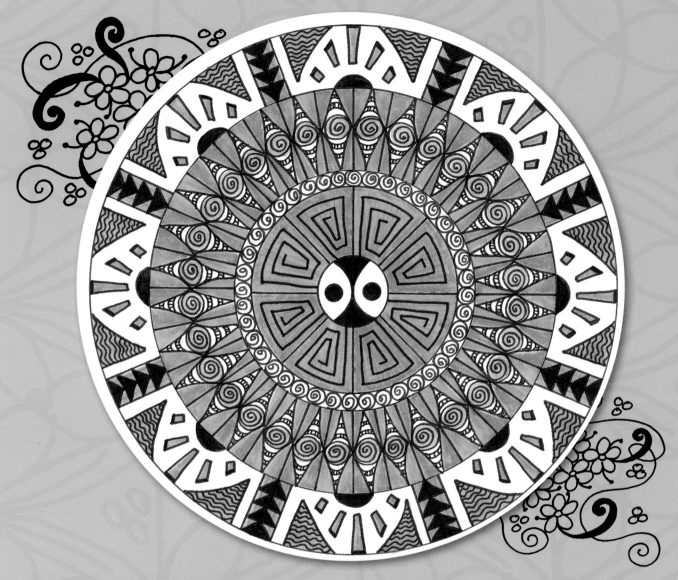

Table of Contents

What You Need

Surfaces
- 70-lb. (150gsm) Strathmore drawing paper [or 50lb. (105gsm)]
- Cardstock (various colors)
- Cold-pressed illustration board
- Strathmore bristol board
- Watercolor paper

Pens
- Pébéo Vitrea 160-series glass paint markers
- Sakura Gelly Roll pen, white
- Sakura Pigma Micron pens, black: .01, .03, .05, .08; red: .05, .08; blue: .05
- Sharpie Oil-Based Paint Markers
- Sharpie Permanent Markers
- Tombow Dual Brush Pens (055 Process Yellow, 158 Dark Olive, 173 Willow Green, 373 Sea Blue, 452 Process Blue, 493 Reflex Blue, 665 Purple, 725 Rhodamine Red, 933 Orange, 992 Sand Brown)

Pencils
- 2B, 4B, 6B pencils
- Derwent Inktense watercolor pencils
- No. 2 pencil
- Prismacolor colored pencils

Other Supplies
- 18-gauge wire
- Acid-free glue stick
- Acrylic craft paint
- Assorted ephemera, collage sheets, stickers
- Blending stump
- Cardboard
- Children's shoes
- Collage sheet
- Cotton swabs
- Craft knife
- Crystal lacquer (Sakura 3D Crystal Lacquer)
- Deck of playing cards
- Decorative stamps
- Double-sided tape
- Duct tape
- E-6000 adhesive
- Fine-grit sandpaper
- Glass paperweights
- Glass tile
- Grosgrain ribbon
- Heat gun
- Hot glue gun with glue sticks
- Iron-on transfer
- Jewelry supplies
- Key ring
- Kilz primer
- Kneaded eraser
- Magnet strips
- Mod Podge, matte finish
- No. 10 watercolor brush
- No. 12 round watercolor brush
- Painter's tape
- Permanent ink pads, various colors
- Photo coasters
- Photo frame
- Poly fiberfill
- Polymer clay (Sculpey III)
- Polymer clay sealer
- Premo! Scupley Shapelets Classic Design Shapes
- Protractor
- Ruler
- Scissors
- Scrapbook paper
- Sculpey clay cutting, rolling, and piercing tools
- Sewing materials
- Small scissors for paper crafting
- Spiral-bound, hardcover journal
- Straightedge
- Templates
- Terra-cotta pots
- Watercolor paints
- White gesso
- Wine bottle holder
- Wine glass
- Wrapping paper

Tribal Zentangle
Marker and pen on cardstock
8" × 8" (20cm × 20cm)

Introduction

I stumbled across Zentangle® quite by accident. Like many other crafters, I was in the midst of researching material on the Internet. My attention was diverted to a link on the side of the screen, directing me toward some unusual design form that I had never seen before. Being the curious-minded person that I am, I proceeded to the link and discovered one of the best "finds" of the crafting industry in the last ten years. This little gem had staying power, and I immediately wanted to learn all I could about it.

Rick Roberts and Maria Thomas are the two genius minds behind creating this unique art form. They discovered the calming effects of drawing simple, repetitive patterns on paper, a drawing technique that unlocks creativity and provides medicinal benefits. It is also simple to learn, requires few materials, and can be done anywhere on a multitude of surfaces.

I should first tell you what this book is not. It isn't a beginner's introduction to Zentangle basics. If you are a beginner, I implore you to first check out the series of books written by Suzanne McNeill or Sandy Steen Bartholomew. Both are Certified Zentangle Teachers® (CZTs). When I first discovered Zentangle, theirs were among the few books on the market that covered that subject matter. They provide all the basic information you'll need to begin your creative journey into the world of Zentangle. The dozens and dozens of patterns showcased in all the books are meant as samples for you to study from and then incorporate into your own designs on paper. As with any skill, you need to start with the basics before you can master the craft. This series of books is the best place to start. You may also further explore the origins of Zentangle by visiting the founders' website at Zentangle.com.

With the above in mind, this book will help you take your Zentangles to the next level. I've written from an artist's point of view so that I could expand on some basic design principles necessary to creating your own patterns. There will be helpful tips on avoiding common mishaps through improper use of materials as well as advice on making your layouts "stand out." Once you incorporate these principles on paper, you will then be guided to a gallery of applications to showcase your designs. My goal is to get everyone to think like an artist … because, if you haven't looked in the mirror lately, you already are one!

Zentangle World
Pen and marker on bristol board
11" × 8½" (28cm × 22cm)

Zentangle and the Great Brain Divide

Betty Edwards's ground-breaking book *Drawing on the Right Side of the Brain* brought to light that we tend to be a very logical or left-brain society, using only a small portion of the creative right side of our brains.

The beauty of Zentangle is that it speaks to both sides of the brain. The repetitive patterns take on a rhythm and logic that is familiar to the left side of the brain, but it's only when we let the right side open up and take over that the pieces or "quadrants" come together to form the end design.

Some of the Zentangle applications in chapter 5 may require a bit more artistic ability. For left-brain enthusiasts, I urge you to try the "upside-down picture" exercise. Turn the image upside-down to force the right side of your brain into action, allowing you to focus on the shapes and lines for a more accurate drawing. You may surprise yourself by unlocking drawing skills you never thought you had. Exercising the right side of the brain will take your designs to the limits of your imagination.

An Art for Both Sides
Although Zentangle appears to lean a little more to the right side, there are specific qualities in this drawing technique that are easily understood by a left-brainer.

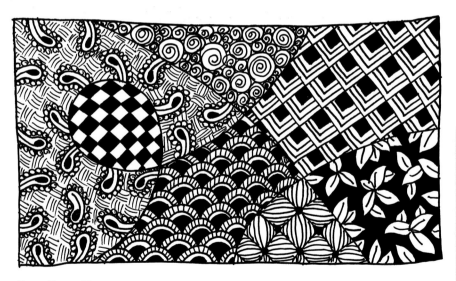

Free-Form Patterns
Pure Zentangle design is meant to be "free-form." No pattern that you render should be considered a mistake. It should be a relaxing experience for the mind and soul, so have fun with it.

Test Your Brain
Clasp your hands together quickly in the most comfortable way possible. Now look down at your hands. Which thumb is on top?

Right thumb on top indicates right-brain dominance. In other words, someone from the creative department wears the pants up there!

Left thumb on top indicates left-brain dominance. If this is you, you might be a bit more analytical in your approach to Zentangles. That's OK too!

There has been much debate over what Zentangle really is. There are those who think it is nothing more than "mindless doodling." Which then escalates to asking, "Can doodling really be considered an art form?" I view doodling and Zentangle as totally different exercises, each serving a specific purpose.

Doodling = Personal

Ordinary doodling serves two purposes: The first is just to mindlessly pass time. This is what students draw on the cover of their notebooks when they are bored during a history lecture. The images and wording on the cover of that notebook will appear random and disconnected. Doodling's second purpose is to serve as a form of journaling, which is commonly found in scrapbook pages. In journaling, the text itself becomes art. Artist Joanne Sharpe is an excellent reference for artistic lettering.

Zentangle = Purposeful

A Zentangle's intertwining patterns have a definite flow and rhythm. You could draw a Zentangle on a notebook, but it wouldn't look like an ordinary doodle. Although it's not in the standard square format, it still connects and relates to the confines of the page, either flowing from the top to the bottom of a paper's edge or unfurling from one corner. Journaling can be incorporated into a Zentangle, as long as it lies within a quadrant or becomes part of the overall pattern, again, with a purpose and connectivity.

Some of the best ways to successfully apply a Zentangle in scrapbooking are to draw directly on the corner or edge of the scrapbook paper, or decorate mats to frame the pictures on the page. You can find inspiration and ideas for this type of application in the project section at the end of the book.

With scrapbooking, you can certainly throw a Zentangle into the same arena as doodling, but you wouldn't consider a doodle suitable for framing and hanging on your wall. Some Zentangle patterns are so interesting and beautiful, you'll want to showcase them as works of art!

Notebook Graffiti
Notebook doodles often look like a tiny wall of graffiti.

Mindless to Mindful

When you first begin practicing Zentangles, you'll consider your approach to drawing to feel "mindless." But, as you gain more confidence, you'll be more "mindful" of what the finished piece will look like.

THE WEATHER WAS PERFECT THAT MORNING. WITH BUCKETS IN HAN[D] WE SET OUT TO COLLECT THE MOST BEAUTIFUL SEASHELL[S] WE COULD FIN[D] ALONG THE SHORE....

PHOTO HERE

Chapter 1
Materials

If there's one thing I've learned in all my years as an artist, it's that practice makes perfect. More importantly, though, experimentation clarifies everything. For every artist who recommends a certain brand of paper, pen or paint, there's another who will say, "Really? That didn't work as well for me."

There is no "one size fits all" when it comes to art materials. You simply have to sample several products to find which ones work best for you. However, there are some basic tools that you should start with to draw your Zentangles. Through my own experience and research, I've determined that the materials covered in this chapter will ensure the highest level of success in your finished pieces.

An Easy Dance to Learn
My play on words illustrates a simple Zentangle fact: all you need to tangle is a Micron pen and a tile!

← **Coastal Vacation Layout**
Mixed media on cardstock
11" × 8½" (28cm × 22cm)

Paper

There are many options of paper and cardstock to suit every surface textural preference and budget. When choosing your Zentangle surfaces, look for papers that are acid-free, archival, heavyweight and have a smooth or vellum finish. These papers will provide a good base for the pen to glide across. I drew my very first Zentangle on bristol board. This is very similar to cardstock in weight, and both types of paper allow for crisp, clean lines.

I recommend buying your paper in the most economical way possible. For example, if you buy a couple of large sheets of archival-quality paper from an artist supply store, you can get a good stack of 3½-inch (9cm) square tiles by cutting them yourself. If you want tiles with a deckle edge, measure the paper, fold it over a large ruler, and gently tear along the ruler's edge. A more efficient method is to cut your squares with clean edges, using a craft knife and ruler.

If you like working in a larger format than the standard-size tiles, purchasing a 20-sheet, 9" × 12" (23cm × 30cm) tablet of bristol paper will certainly be more cost effective. I've found that white cardstock is often cheaper at office supply stores than at craft stores. For further savings, office supply stores also offer larger packages, including colored cardstock.

Making a Deckle Edge
A straightedge and a steady hand are all you need to create a deckle edge, which gives your tiles a museum-quality finish.

Watercolor Paper

If you want to experiment with watercolor paper, choose the smoothest finish possible. If the surface is too rough, your pen may skip or tear the paper, and ruin the tips of your markers. On the plus side, watercolor paper will give a unique softness to your design and is excellent for blended areas.

Cardstock

I purchase vellum bristol white and colored cardstock from an office supply store. The colored sheets work well in note card design and with scrapbook layouts.

Bristol Board

The best all-around surface for beginning tanglers. Bristol board, with its smooth texture and medium weight, holds up well to repeated pen use and ink absorption.

Mixed-Media Tablets

When you want to start using various water-based mediums in the background of your Zentangle-inspired art, opt for papers specifically designed for mixed media.

Pencils

A standard 2B lead pencil will be fine to use when drawing your initial lines onto your tiles. You'll cover up these pencil lines with pen ink later, so it really won't matter. However, for shading purposes, the type of pencil is more important. I recommend a softer lead for adding definition to your pattern. Consider purchasing a 4B or 6B pencil to use for the "gray" areas on your Zentangle. The softer the lead, the more realistic the shading will look in the pattern. If you need to further blend or smudge the gray areas, use a cotton swab or an actual blending stump (shaped like a cardboard pencil) that most art supply stores carry. Refrain from using your fingertips to blend. The oils from your hands can damage the surface of the paper. If you are using a pencil to fill in a solid area of your pattern with gray, I would switch and use an actual gray colored pencil. These pencils should be used for coloring, and regular soft lead pencils are better used for shading.

Choosing Your Pencils
Any standard No. 2 pencil will suffice for drawing initial "strings" or basic designs. Be sure to include a 4B or 6B pencil in your collection for shading applications.

Pens

The resounding tool-of-choice among all CZTs is the line of Micron pens by Sakura. Because these pens contain archival ink, they'll produce a smooth line without bleeding through the paper. When tangling on a 3½-inch (9cm) square tile, the .01 Micron pen offers fine detail. I like working in a larger format, so I rarely use my .01 tip. Instead, I like to use the .05 for most of the line work and a .08 pen for filling in black areas.

Sharpie Permanent Markers are another option. Their pen tips are not as fine, but they do offer a wider range of colors. Sharpie pens are especially useful when working on fabric items such as T-shirts, tennis shoes or hats. Before you decorate a T-shirt, slide a piece of cardboard underneath the top layer of fabric to stabilize the shirt. You can also iron freezer paper to the underside of the shirt to hold the fabric in place. Whichever method you use, you'll need to heat-set the shirt after you're finished drawing the design. Remove the freezer paper or cardboard from underneath the shirt and then iron or throw the item into the dryer to set the ink.

Zentangle MVPs (Most Valuable Pens)

Purchase a good assortment of pens with different point sizes. This will allow you to tackle the thickest line or provide the most delicate detail.

Pens for Unusual Surfaces

Before you know it, you'll want to apply these pens to all kinds of surfaces, and you can. Keep in mind, though, not all surfaces are conducive to these pens. Stay away from surfaces with a slick coating, or your pens will smear easily. For example, if you wish to decorate a white box, choose one with a smooth, matte finish. Glass is, of course, a slick surface, so you'd want to use paint markers specifically used for that type of surface.

How about gourds? I've seen some exquisite Zentangles using this format. The surface is smooth enough to draw onto directly with the Micron pens, or you can apply a coat of gesso first to create a white background for your design.

If you're starting with a black surface, try the white gel pens for an interesting and different effect. The variety of surfaces is endless. Get inspired by what other artists have conquered and find your own surface to tangle with!

A View From the Top
When wrapped carefully, this box is reusable: a nice bonus with all the time and effort put in the design.

Paint Markers and White Gel Pens
The Gelly Roll pens by Sakura and Sharpie paint markers are excellent options for tangling enthusiasts. They both provide an even flow of color and are long-lasting.

Tangled Gift Box
A standard white gift box goes from plain to insane with a decorative paper-wrapped bottom and tangled lid.

Portable Kit

For a portable Zentangle kit to keep in your purse or bag, either hole-punch your squares and join them with a binder ring or insert them into a small notebook. Just remember to keep a pencil and a few pens with it. Now you're ready to "tangle" when the mood strikes or while you're waiting in the dentist's office! Don't be surprised if you get some curious stares from onlookers. This is the type of art form that's intriguing and addictive. They're going to want to know what you're doing, and you might just create a few Zentangle enthusiasts in the process.

Creating Your Kit
You can assemble a portable Zentangle kit quickly with leftover cardboard, scrapbook and watercolor paper. Keep the pencil and pens securely attached to the front cover with Velcro.

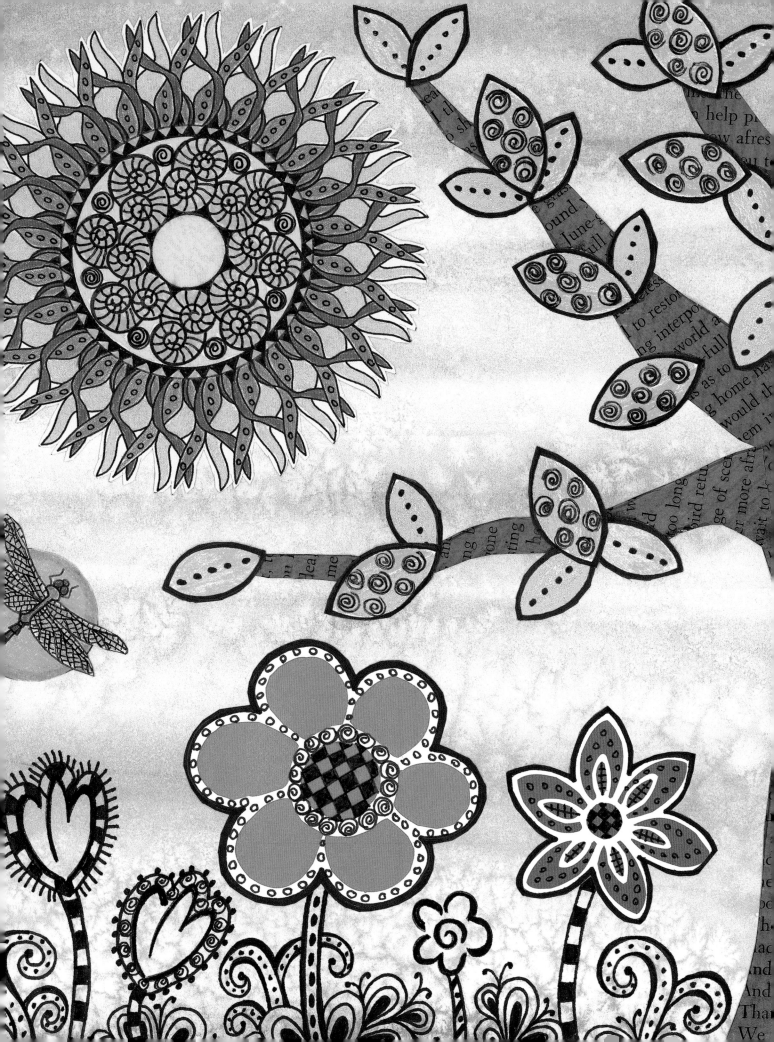

Techniques

Before we move on to creating your own unique Zentangle designs and projects, let's review the techniques you need to create beautiful, balanced Zentangle drawings.

You've heard the expression, "That (painting, drawing, etc.) is so pleasing to the eye." It doesn't mean the picture is simply beautiful; it means the lights and darks are evenly distributed across the paper, resulting in something that is literally pleasant to look at. The sign of a good piece of art is one that allows the eye to move freely around the design. Curved lines will create movement, and the lights, darks and grays will give the piece substance. We'll examine each of these topics separately.

← Summer in Georgia
Mixed media on cold-pressed illustration board
11" × 9" (28cm × 23cm)

Balancing Act
Balanced distribution of lights and darks will make your tangles more pleasing to the eye.

Visit CreateMixedMedia.com/Creative-Tangle for FREE bonus materials.

In my opinion, the initial "strings" that you apply to your paper or tile should always be curved. Curved lines create movement and interest, and they form unusual shapes for all the separate quadrants within the piece. Your eye can't focus on just one area, because it is constantly moving around, and that's a good thing. Symmetry is boring. Make sure your Zentangles show their curves. When you combine curved lines with no borders, it makes the design even more appealing.

Get Free Stuff!

Don't forget to download your free *Creative Tangle* bonus materials at CreateMixedMedia.com/Creative-Tangle.

Balanced Art

This illustration is a good example of achieving balance within an art piece. It is also the very first Zentangle I ever attempted. I used this drawing as a crash course to learn as many patterns as possible, so I wanted to practice and showcase them on a much larger surface.

← In the Beginning
Ink and pencil on bristol board
10" × 8" (25cm × 20cm)

Shading

Just as lines create movement, the black ink and gray pencil shading on the white surface add rhythm. The key is to make sure that your dark or "filled in" patterns are equally represented from top to bottom.

The gray shaded areas add depth and dimension to the piece. The resulting shadow gives the illusion that the pattern is "leaping off the page," as though you could reach out and touch a three-dimensional shape.

Aside from shading, I also use the gray pencil as a separate color to balance the design. Even when I had thought I had completed most of the Zentangle, I went back in and changed some of the pattern shading and added more dark areas as needed.

Another shading method is *pointillism*. For this technique, apply dots of black ink repeatedly onto the paper's surface to achieve varying degrees of light to dark. The more dots that appear on the paper, the darker the shading will be. (See the Tangled Masterpiece project in chapter 5 for more information.)

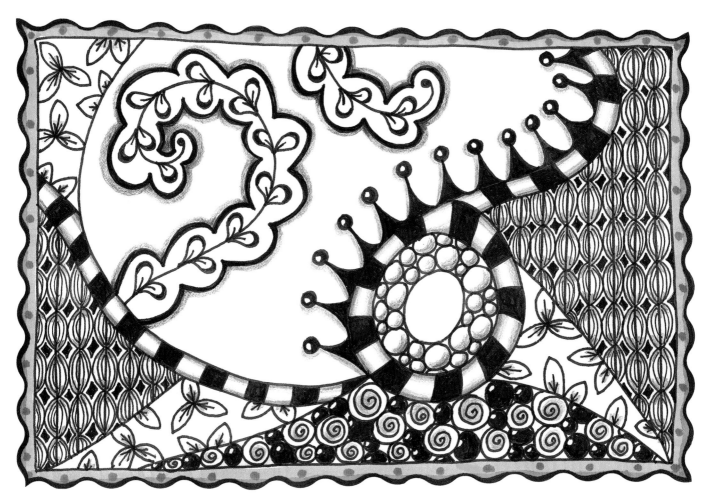

Well-Distributed Darks

I put predominantly dark patterns in adjacent corners, with just a few dark patterns in the middle. This balances the overall design and causes the eye to bounce freely from one section to the other.

Visit CreateMixedMedia.com/Creative-Tangle for FREE bonus materials.

Self-Evaluation

Self-evaluation and reworking patterns as needed is key to creating beautiful, balanced Zentangles. To better understand this process, I encourage you to view some of the many video demonstrations available online. Look for videos of larger-format Zentangles that run between 3–8 minutes long. (The actual designs probably take 20–30 minutes to complete, but the videos are sped up.)

As you watch the videos, you'll notice several points when the action seems to stop and start. This is the artist pausing to decide which pattern she will place on the page next.

Sometimes you'll notice an artist go back to a seemingly finished section of the paper and add something more. It's as if you can hear her saying, "I've got too many dark patterns in this lower corner. I need to fill in more areas at the top to balance this."

You'll see that an artist may choose patterns based on whether she wants her completed design to be viewed vertically or horizontally. Does it matter? The point is that she knows there is something about her piece that isn't quite right, and she has the knowledge to change it for the better. Through practice, you will learn to evaluate your work and make these types of decisions yourself.

Zentangle Videos
For quick instruction or inspiration in Zentangle techniques, view one of the many YouTube videos available on the Internet.

Tangling Shapes

One of the easiest ways to create a Zentangle-inspired art piece is to enclose the design within a recognizable shape. In doing so, you eliminate the intimidation or frustration of drawing something artistic, and can then focus solely on the patterns themselves. Study the examples on the next few pages to get an idea of the many directions you can take this technique. As you'll see, for every direction, there are as many ways to get there.

If you don't have the artistic ability to draw your own realistic shape, don't worry about it. You can trace a shape out of a magazine or coloring book and make your own template to use for your Zentangle. There are also many free clip-art websites that will allow you to print images that you can enlarge to whatever size you need for your design shape. I recommend drawing or printing directly onto heavy-weight cardstock to make your templates, so you can use them again and again.

Building a Template Collection
Print out several basic-shaped images to have a library of templates to trace for future art pieces.

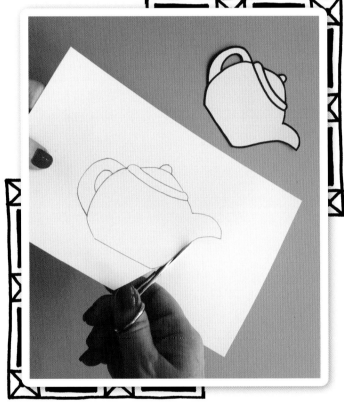

Cutting Shapes
For images with inner spaces, such as the teapot handles, use a craft knife or small pair of scissors to cut these inside areas first. This will prevent your template from tearing when you cut around the outer edge.

Name Shapes

Almost every kid loves to see her name incorporated into a design or art piece that she can hang on her bedroom door. Depending on the length of the child's name, you can enlarge it accordingly. One way of filling in the shapes is to take each letter of the name and use only patterns with titles that begin with that same letter. Of course, only those who are familiar with the names of the Zentangle patterns would know what was going on. For additional pattern name ideas, reference

AlphaTangle by Sandy Steen Barthomew or visit TanglePatterns.com.

Another idea would be to think of a word that describes your child using each letter of her name. Take those words and incorporate them into each letter in the design. I could probably write a whole chapter with ideas for just this one example, but I think this gives you a good start.

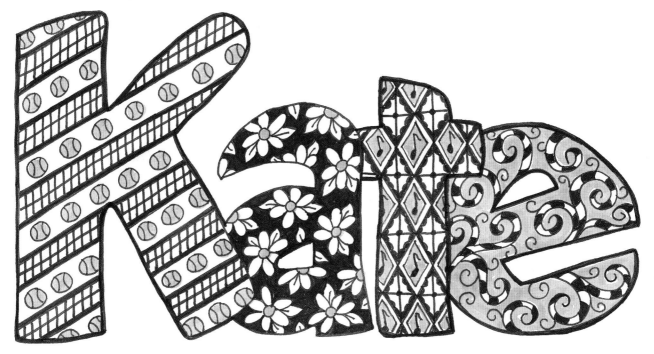

Simple Patterns
You can personalize your design by further embellishing some of the less-complex patterns. How about turning circles within a pattern into softballs or soccer balls? Maybe a musical note could be placed inside a diamond-shaped pattern? Think of other hobbies or interests that your child has and let the design reflect those images.

Zentangle Pattern Names

I've observed a definite trend in naming Zentangle patterns. Designers enjoy taking obvious words and changing them to create a unique twist. A name like "Spools," for example, becomes "Spoolz." I often find that the inspiration behind how the designer came up with a particular title is as fun and interesting as the pattern itself!

Holiday Shapes

You can use the techniques you've learned so far when making seasonal greeting cards. Using templates, trace an image of a Christmas tree, ornament or dove. By inserting a phrase into the overall design, it further emphasizes the seasonal greeting.

You could make some fun birthday party invitations by drawing patterns within the number that represents the person's age. The applications for drawing patterns inside recognizable shapes are endless.

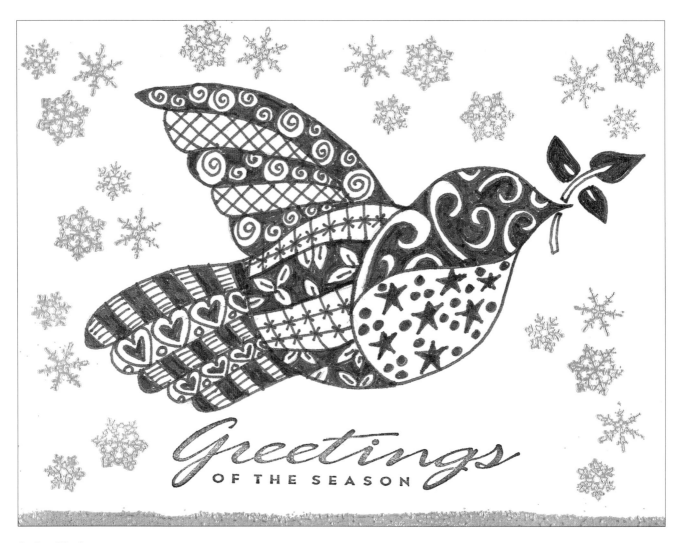

Color Choices
You could make your design black and white and then fill in some of the pattern areas using reds and greens. I chose blue as the single color for the dove design, because I like blue and silver together. I added a few stamped images to the design and embossed the bottom edge of the card with silver powder.

More Shape Inspiration

A number of CZTs use stamped images on the paper first, then tangle around them. Suzanne McNeill likes to create her own artistic imagery with watercolors, and then draws a Zentangle on top of it. The result is absolutely beautiful. You can find many more examples of this technique, by watching some of the inspiring tutorials on the Internet.

Check out my Tangled Masterpiece in chapter 5. This is another example of taking something familiar and adding a Zentangle to it. In this case, I printed the very recognizable face of the Mona Lisa and tangled the rest—including the background of the famous painting. As you can see, it's very easy to push the envelope with this medium.

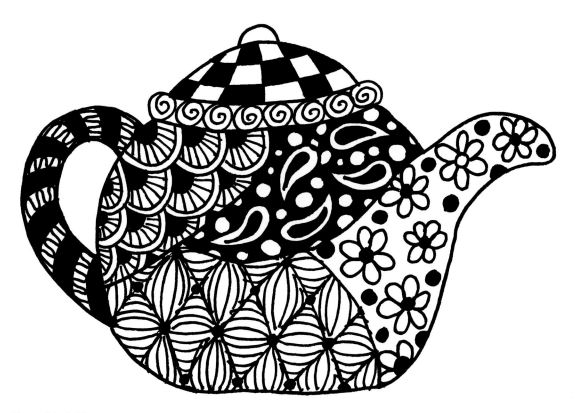

I'm a Little Teapot
Starting with a "short and stout" shape, section off areas within the outline and fill each with whimsical patterns. Further customize this framable piece by incorporating the colors of your kitchen. You can do this with any simple, recognizable shape.

Chapter 3
Create Your Own Patterns

This chapter will train your eye to look at objects or patterns in a certain way that simplifies them into easy-to-draw lines and shapes. Once you master this process, you'll be able to create your own patterns. Won't that be wonderful to supplement your collection of favorite Zentangle patterns with some that are your own creation?

Maybe you've already thumbed through a few pattern books and wondered, "Why couldn't I have come up with something like that?" The Zentangle founders, CZTs and other creatives have one thing in common:

inspiration. Before creating a pattern, each artist is inspired by something either in the real world or in her own mind. She then takes that vision, and, through her own methods, translates it onto paper.

I can't claim to know what method each and every person uses to create patterns, but I can point you in a direction that will certainly work for you. There's no big mystery here. You need only remember three things: simplify, simplify and simplify! And I promise, the process will be an easy one to grasp.

Start by Embellishing

Before we delve into creating your own patterns, let's discuss the process of embellishing patterns you already know. This is the easiest and quickest way to change an already-existing pattern into one that is truly your own.

What type of patterns work best for embellishment? Since you'll be adding more detail to the finished piece, start with something very basic. Look for diamond shapes or checkerboards, anything with open shapes that you can fill with another embellishment. Lines within a basket-weave pattern or curving vines are examples of simple lines that you can add to. The leaves on that vine could be changed to hearts, stars, smiley faces, or even letters of the alphabet. Fruit or coffee cups would fit in nicely with a kitchen-inspired Zentangle, especially if used with a checkerboard tablecloth pattern. Get the idea?

It's easy to "theme out" a Zentangle by using objects and pattern types that go together. A school mascot (such as a paw print) or other emblem would be perfect for designs used in scrapbooking or other items you want to personalize. (See chapter 5 for an example I created using my daughter's high school colors.)

Need inspiration or ideas for embellishments to use? Choose from hundreds of clip-art images available on the Internet. Remember that the image you select should be basic enough that it could be drawn using a template. You're looking for simple outlines with no detail. Virtually any simple shape can be added to an existing Zentangle pattern to make it more interesting. Experiment and enjoy!

The Simplest Place to Start
I started this Zentangle with open diamond shapes and both curved and straight lines. I chose to embellish with swirls, pinwheels and thin lines, but the original simple pattern could have gone in a hundred different directions.

Simplify the Shapes

When my daughter was in the first grade, she took an annual children's workshop at a local art center. Using acrylic paints on canvas board, the children were told to re-create a famous painting. In this particular case, they copied one of my favorite Impressionist painters, Claude Monet.

Much later, when I unwrapped this precious painting Christmas morning, I was nearly moved to tears. Not only did I immediately recognize the artist, I even knew what painting inspired it! My daughter was spot-on with her use of the same muted, cool-tone colors that are so indicative of Monet's work. She had also managed to break down the elements of the bridge over the pond into simple, recognizable shapes.

Was my daughter's painting drawn correctly? Of course not. But, when she was given a difficult task, she broke it down in simple shapes and forms. My daughter painted exactly what she saw. Admittedly, most children are fearless when learning something new. But even adults know a task is less daunting when broken down into simple steps.

Just as a CZT will break down a Zentangle pattern from start to finish, you need to create patterns using the same approach. Get yourself into the mind-set of a first-grader and see patterns and images in a different light. To this day, my daughter's painting hangs in our upstairs hallway, alongside the actual print of Monet's, *Water Lily Pond*. It's a continual reminder of how simple life can seem through the eyes of a child.

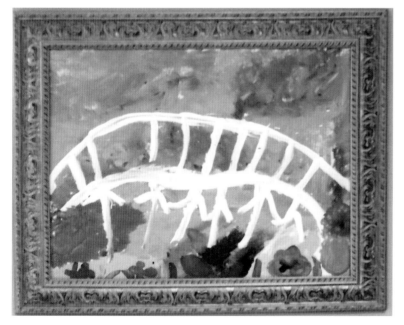

Break It Down

My daughter's painting is primitive, isn't it? But look again. All the basic elements are there. Notice how she extended the white lines of the bridge to indicate the reflection of the image in the water below?

Find Patterns in Your Home

Probably the most obvious form of inspiration will come from already-existing patterns you can find in your house. Common pattern sources may include wallpaper, tiled floors or walls, pottery, area rugs, and fabric from the clothes in your closet.

Before starting to simplify the designs we see, let's try some exercises to get our thought process on track. What if you were limited to interpreting everything you see into only six different shapes? This may not seem like enough to work with, but it absolutely will be. Remember, Zentangle patterns are meant to be repeated again and again on your paper. If it's too detailed or complicated, you're not going to be in a Zenlike state of mind, are you? Keep the pattern simple and easy to repeat.

Now we will go through design exercises so that you can practice this technique. You'll be able to see how I interpreted each of the objects in a picture into one of the following six shapes: rectangle, square, circle, oval, diamond and heart. (Lines are considered separate from shapes.) Once you get a feel for it, take a stroll around your own house and try the same exercise on objects you see. The shape lines you use can be any thickness or quantity, but stick to the six basic shapes. Take a blank notepad with you and begin sketching those shapes into a pattern, as I did. You can always further embellish your design, but just stick with a basic pattern for now. I'm sure you'll find plenty of inspiring designs indoors to keep you busy for awhile. Later, we'll go outside to explore a whole other world of options.

Pattern Design 101
Notice the open squares and the varying thickness of the lines in the border pattern. These observations are the foundation for learning to create patterns from your inspiration piece.

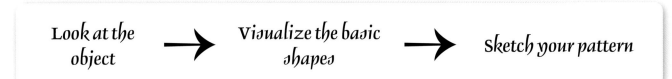

Order of Operations
Follow these simple steps to create your own Zentangle designs.

It's possible to find inspiration from everyday objects. In the foyer of my home there is a topiary plant that has very interesting shapes. It looks rather busy, but it can be broken down into two basic shapes.

Materials
- Bristol board
- .05 black Sakura Pigma Micron pen
- 2B pencil

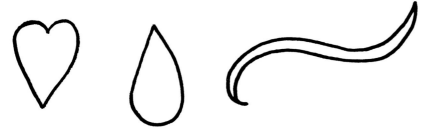

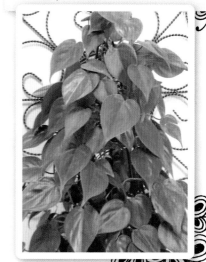

Find the Shapes
Find the basic shapes in the topiary. I see a heart, a teardrop and a continuous line forming a squiggle.

Create the Pattern
Pencil in a continuous line to form the plant vine. Add the heart and teardrop shapes to the vine, evenly spacing the shapes. Next, for an added flourish, apply a swirl to each of the shapes. Embellish the vine with a checkerboard pattern and additional swirls. Go over all the lines with a .05 black Micron pen and fill in every other square shape on the vine.

Next, let's look at an area rug. We have a couple of simple options for a full pattern and a border on this one. This is a good example of a pattern that can be embellished further. Let's start with the border pattern.

Materials
- Bristol board
- .05 black Sakura Pigma Micron pen
- 2B pencil

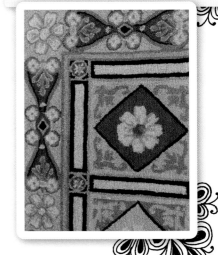

Find the Shapes
Find the basic shapes in the rug. I see a heart, a circle and a diamond.

Create the Pattern
For the border pattern, I stayed true to the design of the rug's edge. Start at the center and work your way out. Pencil in the center diamond with four circles. Add a ¾" (19mm) line on either side of the diamond (the lines will go through the heart shapes). Draw the hearts with swirls on both sides. Draw the mirror image of each heart and continue the pattern, attaching shapes as you work outward. To finish, go over the pencil lines with a .05 black Micron pen.

Area Rug, Center Pattern

If I were creating a full pattern for this, I would use the section in the center of the rug. This one is fairly easy to visualize as a Zentangle pattern because it is practically drawn out for you. Use the open shapes to change up the design. Add flowers inside the diamonds, or insert hearts or even a monogram. Leave the smaller squares blank or embellish them. These designs can be very versatile!

Materials
- Bristol board
- .05 black Sakura Pigma Micron pen
- 2B pencil

Find the Shapes
Find the basic shapes in the rug. I see a circle, a rectangle and a diamond.

Create the Pattern
Using a 2B pencil, start with a grid of squares and rectangles, then treat each shape separately for further detail. I used diagonal lines, solid boxes and swirls. Finish inking with a .05 black Micron pen.

I was intrigued by a few pottery pieces I have in my kitchen and living room. Just think, I never even looked at the patterns on fabrics in my closet! There are so many objects to get the creative juices flowing it'll blow your mind. So just stick to the less complicated ones. Now, back to the pottery. Again, we'll draw out a border and a full pattern. I combined a couple different areas on the kitchen piece to form the border shown.

Materials
- Bristol board
- .05 black Sakura Pigma Micron pen
- 2B pencil

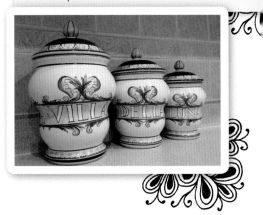

Find the Shapes
Find the basic shapes in the pottery. I see a triangle, a circle and curved lines.

Create the Pattern
Begin by drawing four lines, leaving 1" (25mm) between the two middle lines. Add the triangle shapes and half circles along the edges. Add small circles to the outer triangle shapes and insert the curved lines between them. Finish by inking over the pencil lines with a .05 black Micron pen.

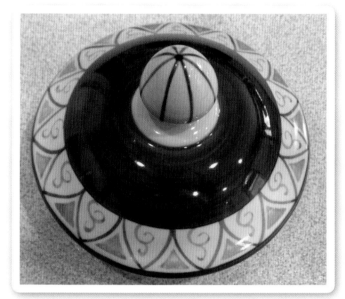

Mandala

The top of the canister reminds me of a mandala (a circular design, divided into separate sections, containing graphic and often symbolic patterns). If you combine a mandala with a Zentangle, you get a zendala.

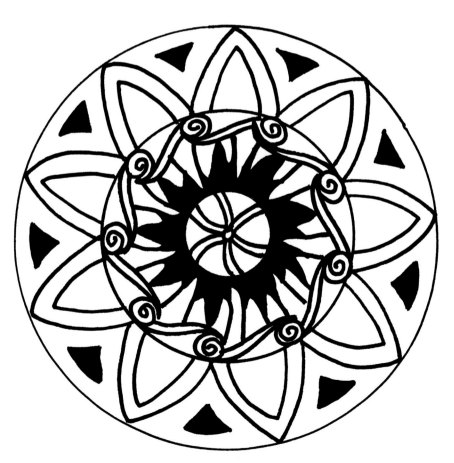

Zendala

Here is an example of a zendala I drew based on the lid of the pottery piece. I drew the handle and edges almost exactly as they appear on the lid. I created a starburst effect beyond the handle and edged the center section with swirled lines.

Oriental Vase

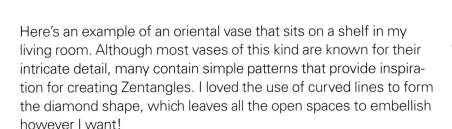

Here's an example of an oriental vase that sits on a shelf in my living room. Although most vases of this kind are known for their intricate detail, many contain simple patterns that provide inspiration for creating Zentangles. I loved the use of curved lines to form the diamond shape, which leaves all the open spaces to embellish however I want!

Materials
- Bristol board
- .05 black Sakura Pigma Micron pen
- 2B pencil

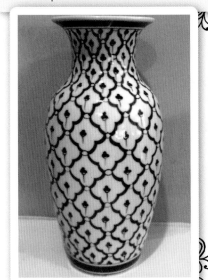

Find the Shapes
Find the basic shapes in the vase. I see an oval and curved lines facing upward and downward.

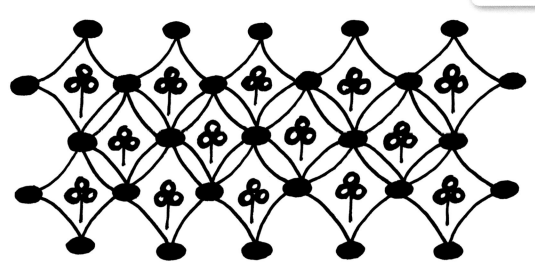

Create the Pattern
First, lay in the five rows of oval shapes. You may use a grid to keep everything evenly spaced. Connect the ovals with the curved lines going upward, downward and along the sides. Draw the petal shapes that connect the three inner rows of ovals. Draw a line and three circles to make the clover design in each open shape. Finish inking everything with a .05 black Micron pen.

Interior Designs

Let's take our pattern designing a step further and create complete Zentangle patterns, inspired by patterns and objects found inside.

The following design demonstrations include photos of items found in and around my own home. Although some of my choices may surprise you, these are all good examples of the basic shapes and lines you're looking for. I'll walk you through each pattern design, step by step.

Pencil First

Using a pencil first with any of these exercises is optional. As you gain confidence, you'll be able to start drawing directly with a Micron pen.

Dress Fabric

Fabric patterns are great for inspiration. While looking at this busy, graphic dress pattern, I knew I had to simplify it. I focused on one interesting area and let my pattern develop from there.

Materials
- White cardstock
- .05, .08 black Sakura Pigma Micron pens
- No. 2 pencil

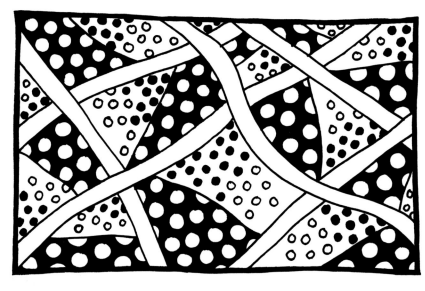

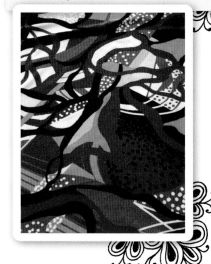

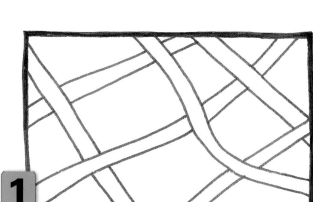

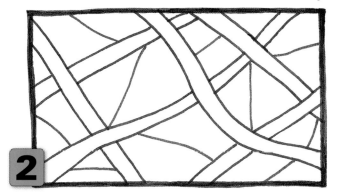

With two different types of swirls and a leaf shape, this shower curtain offered several design options. I chose to combine them both in my pattern.

Materials
- White cardstock
- .05, .08 black Sakura Pigma Micron pens
- No. 2 pencil

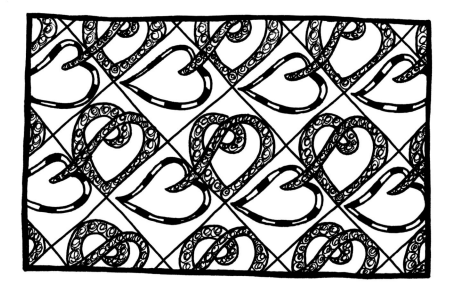

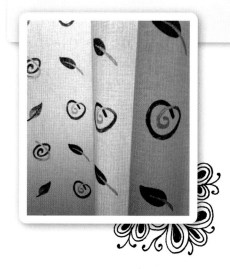

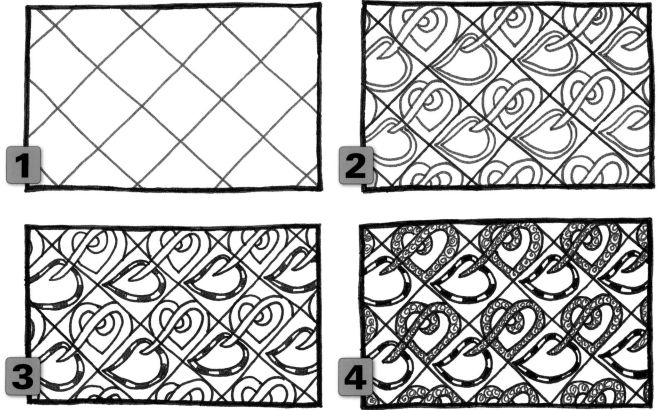

Wall Hanging

This wrought-iron wall hanging was an obvious choice for pattern inspiration. I chose to work with the central design, but the outer edges would also have made a successful border design.

Materials

- White cardstock
- .05, .08 black Sakura Pigma Micron pens
- No. 2 pencil

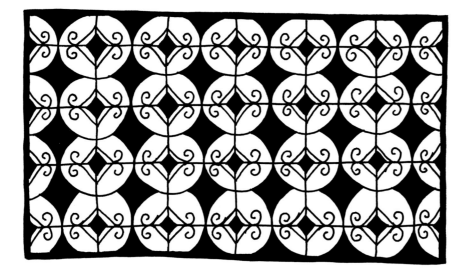

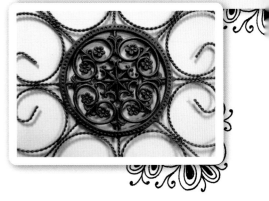

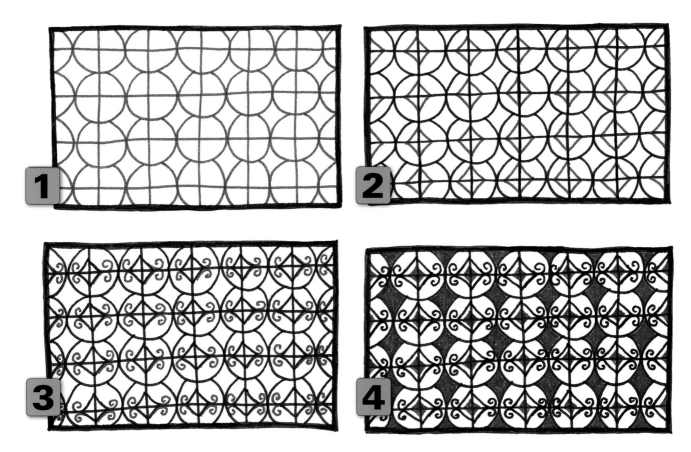

Furniture pieces are an unlikely source for inspiration, but wood carvings and wrought-iron curves are worth a second look.

Materials
- White cardstock
- .05, .08 black Sakura Pigma Micron pens
- No. 2 pencil

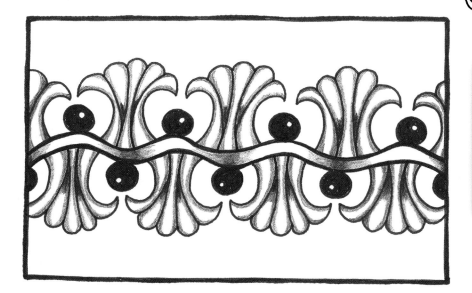

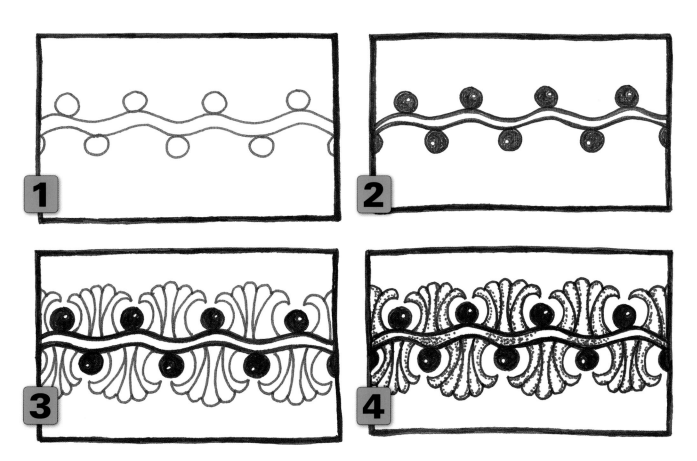

1

2

3

4

This is the wallpaper design in my first-floor bathroom, but you don't have to be limited by your home. For a library of ideas, take your camera or smartphone to a nearby home-improvement store and spend some time thumbing through the wallpaper sample books.

Materials
- White cardstock
- .05, .08 black Sakura Pigma Micron pens
- No. 2 pencil

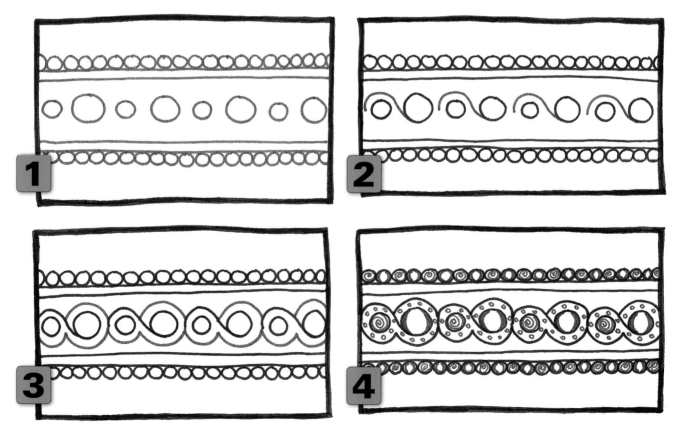

Take a trip to your local craft or art supply store to view all the different varieties of papers available. Find several that speak to you and let the design process begin.

Materials
- White cardstock
- .05, .08 black Sakura Pigma Micron pens
- No. 2 pencil

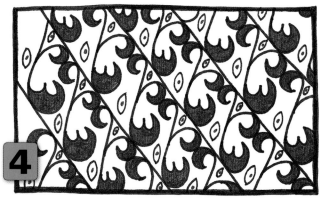

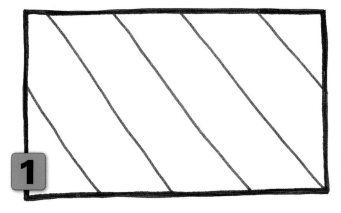

1

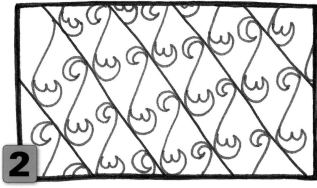

2

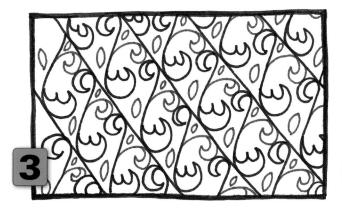

3

4

Vanity Container

Search your home for unique vessels, vases and storage containers. This small trinket box that sits on my bathroom vanity provided several great ideas for patterns.

Materials
- White cardstock
- .05, .08 black Sakura Pigma Micron pens
- No. 2 pencil

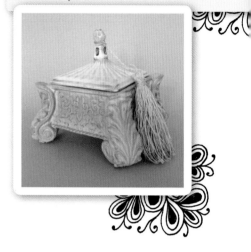

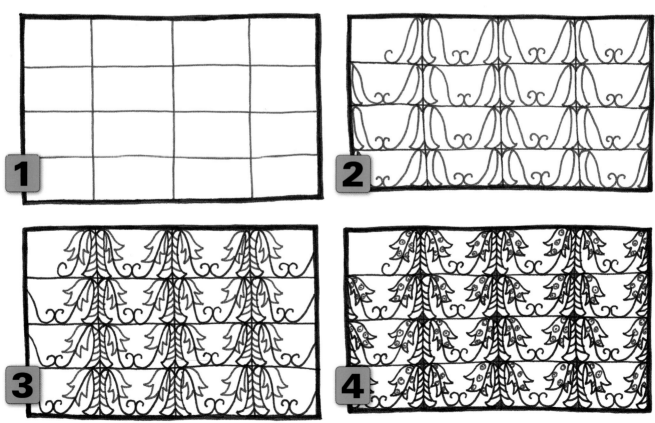

Paper or fabric doilies may seem a bit old fashioned, but their intricate patterns are on the cutting-edge. The ones I have are from the 1950s, but they are readily available in stores or online.

Materials
- White cardstock
- .05, .08 black Sakura Pigma Micron pens
- No. 2 pencil

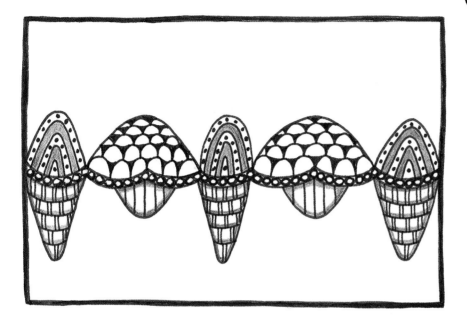

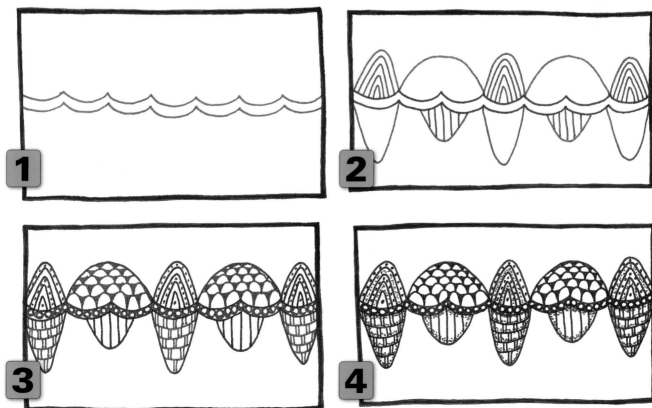

Nature has been a constant source of inspiration to artists. Nothing is more perfect and beautiful than what we see all around us in the great outdoors. I happen to know a thing or two about gardening and landscape architecture. I need only step outside to have an endless supply of sights, colors and textures to inspire me.

If your backyard consists of a concrete patio with a broken swing set in a weed-filled lawn, fear not! Find a park, nature trail, botanical garden or even someone else's backyard that you can "borrow" for inspiration. Take along your digital camera to capture these pieces of inspiration to store in a permanent idea file later.

Look closely at the photos in this section. You'll see an array of different leaf shapes, textures and flowers. The more you observe, the easier it will be to recognize all the Zentangle patterns nature has to offer. Then study each pattern diagram to see how I interpreted nature's basic shapes into a design.

Adding Color

It's only natural to want to bring out the vivid colors in flowers. Many floral and other botanical shapes have already been transformed successfully into Zentangle patterns using just black and white. Color, however, does take it to a whole other level. I've included one sample with color to illustrate how it elevates the pattern into a more realistic and artistic category, and we will discuss this further in chapter 4. In the meantime, keep all of the practice tangles you create from the exercises in this chapter. Since you're using permanent ink pens, you can apply color over the top of your design later.

Specific Shapes
I focused on the specific leaf and flower shapes of my home-grown perennials, translating the patterns into the designs in this section.

Tangled Discovery Zone
My garden area is not only a relaxing retreat, but a place that holds many Zentangle patterns waiting to be discovered.

Fern

The quantity of delicate leaf shapes on a fern offers an array of design options for filler and borders alike.

Materials
- White cardstock
- .05, .08 black Sakura Pigma Micron pens
- No. 2 pencil

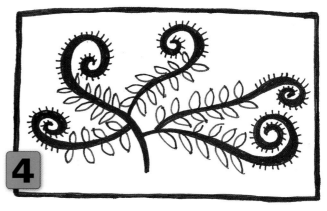

Design Demonstration
Vine

The interaction between the leaf shapes of winter creeper and the tree's texture allow for two different pattern designs in one. The addition of color makes the climbing plant pop off the surface.

Materials
- White cardstock
- .05, .08 black Sakura Pigma Micron pens
- No. 2 pencil

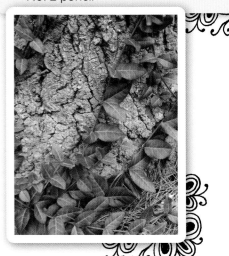

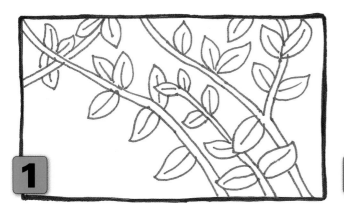
1

2

3

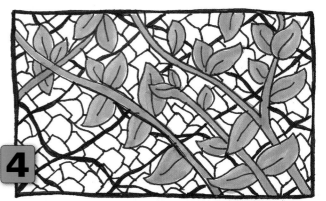
4

Whether elongated or wide, the hostas' dramatic leaf shapes are easy to draw and a favorite of mine for dense, repetitive patterns.

Materials
- White cardstock
- .05, .08 black Sakura Pigma Micron pens
- No. 2 pencil

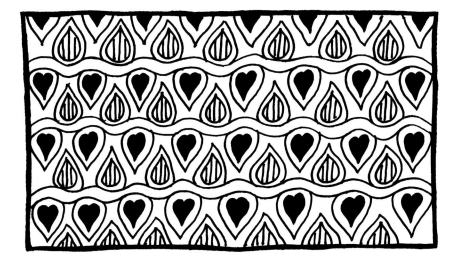

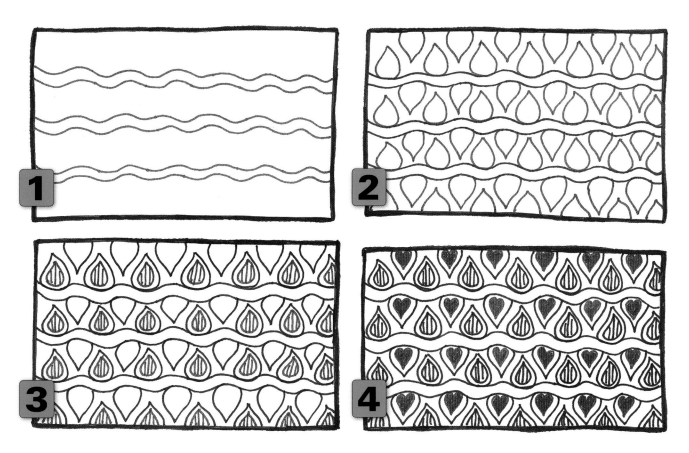

Because of its natural trailing growth habit, ivy is perfect for Zentangle border designs.

Materials
- White cardstock
- .05, .08 black Sakura Pigma Micron pens
- No. 2 pencil

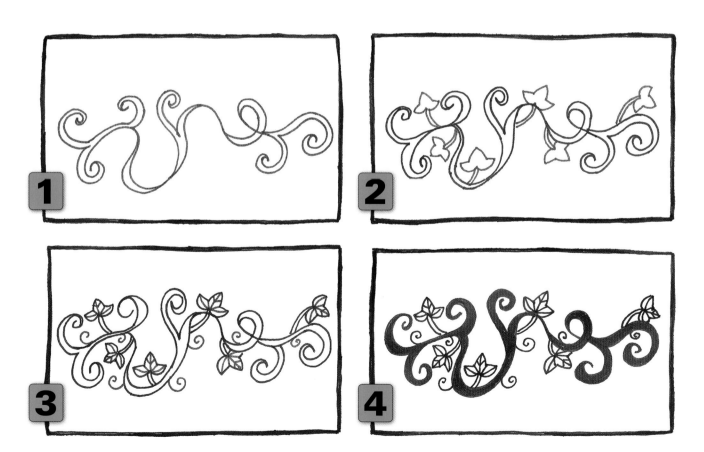

Tradescantia or spiderwort has a distinct triangle-shaped blossom. I stuck with a geometric theme when creating this pattern.

Materials

- White cardstock
- .05, .08 black Sakura Pigma Micron pens
- No. 2 pencil

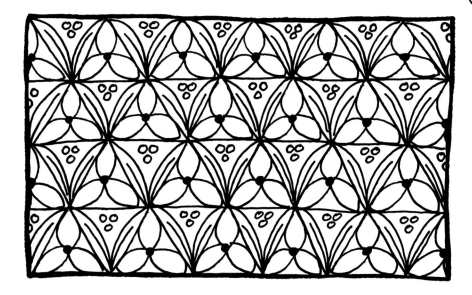

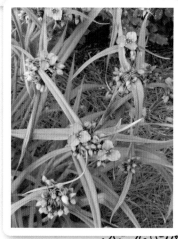

1

2

3

4

The lines running through tree bark may seem simple, but the texture lends itself to wonderful shading opportunities. Use the softer lead pencils to add dimension to this pattern.

Materials

- White cardstock
- .05, .08 black Sakura Pigma Micron pens
- No. 2 pencil

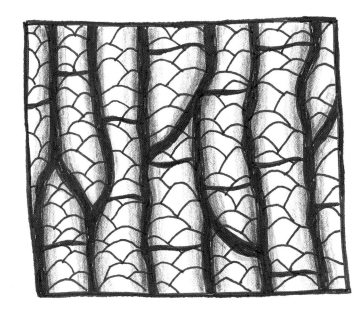

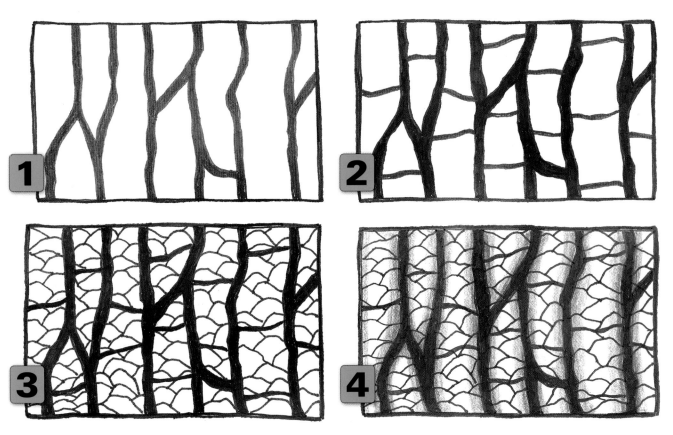

The bold basic shape of the petunia is fairly easy to imitate. Not only do you achieve a realistic interpretation, but the pattern fills in a space nicely.

Materials
- White cardstock
- .05, .08 black Sakura Pigma Micron pens
- No. 2 pencil

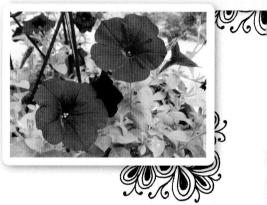

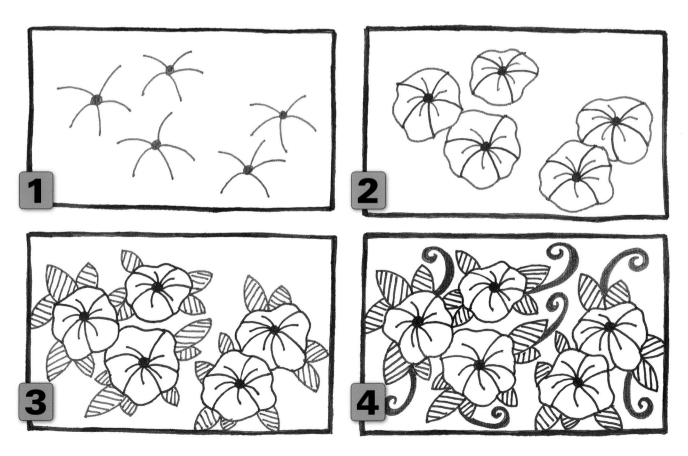

Spiraea

I enjoy taking the tiny flower clusters and wispy tendrils sprouting from the spiraea plant and exaggerating these components into fun swirls and dots.

Materials
- White cardstock
- .05, .08 black Sakura Pigma Micron pens
- No. 2 pencil

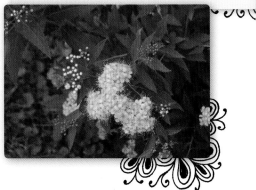

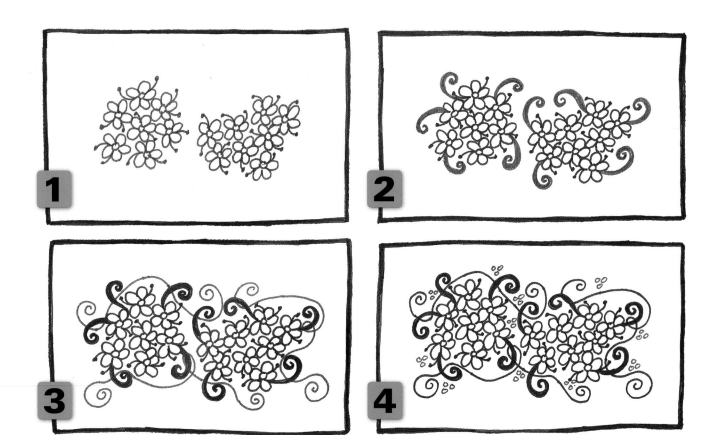

Publish Your Patterns

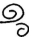

Once you feel confident in creating your own patterns for Zentangle, you may want to consider submitting them for possible publication on TanglePatterns.com. This is a wonderful resource for CZTs and tangle-enthusiasts alike. There are hundreds of patterns for you to view with step-by-step instructions for drawing them. The website is run by Linda Farmer, who encourages everyone to use this invaluable library of patterns to supplement the many Zentangle books available.

One of the best ways to benefit from the site is to join its free email list. You will receive new pattern postings almost daily. You can view the pattern instructions and print them if you'd like. I have a whole folder full of patterns that I've collected from this website.

There are specific submission guidelines, so read them carefully before sending any of your patterns.

They are looking for original patterns, not embellished designs from existing patterns currently on the Web or in books. Feel free to embellish existing patterns as we discussed previously, but only for your own personal use. Copyright infringement is greatly frowned upon in the art world. Please make sure that no part of the pattern you submit is someone else's work.

There is no guarantee that every pattern submitted will be published, no matter how original it is. There are other factors in determining what is appropriate and useful for the website. Just remember, the closer you follow the submission guidelines, the better your chances of seeing your work in print.

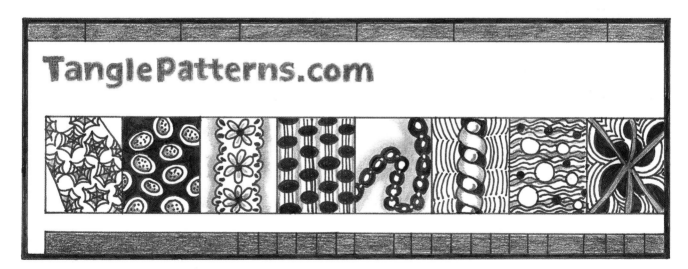

Publish Your Patterns
You do not have to be a CZT in order to be considered for possible publication. I have seen many designs on TanglePatterns.com that were submitted by ordinary people with a shared love for this unique art form.

Awakening
Pen and marker on cardstock
7" × 8" (18cm × 20cm)

Chapter 4
Color Your World

There are many people who believe all Zentangles should be done in black and white. If you consider yourself to be a "purist," then it's perfectly fine to stick to the original method. However, the more I researched this art form, the clearer it has become to me that there are no set rules on how far you can take Zentangle. The stage has been set—what you perform on it is strictly up to you. I'm an artist; so my choice is to delve into the world of color. I suggest that you first get comfortable with black and white before experimenting with color.

Although I have a good understanding of color, the process of applying it to Zentangle design was a new experience for me. There are so many different directions available when you start to introduce color into the black-and-white patterns. Chapter 5 includes some favorite projects that I discovered while experimenting with color Zentangle. First, let's discuss some basic principles of color theory that will bring your patterns to life.

Over the Rainbow
Whichever direction you take your standard black-and-white Zentangles, make sure they make it over the rainbow a few times. You'll be glad they did!

Visit CreateMixedMedia.com/Creative-Tangle for FREE bonus materials.

Color Theory and Zentangle Design

You've heard the saying, "In this world nothing can be said to be certain, except death and taxes." Well, you can add changing color palettes to that quote! From the fashion runways to the paint cans in your local home-improvement store, color trends change yearly and seasonally.

Color options are endless and really do come down to personal preference, but there are tried-and-true color theory ideas that can help you choose colors for your Zentangle designs. First, let's become acquainted, or re-acquainted, with our friend the color wheel. We'll use the wheel as we learn about monochromatic, complementary and analogous color schemes in the following pages.

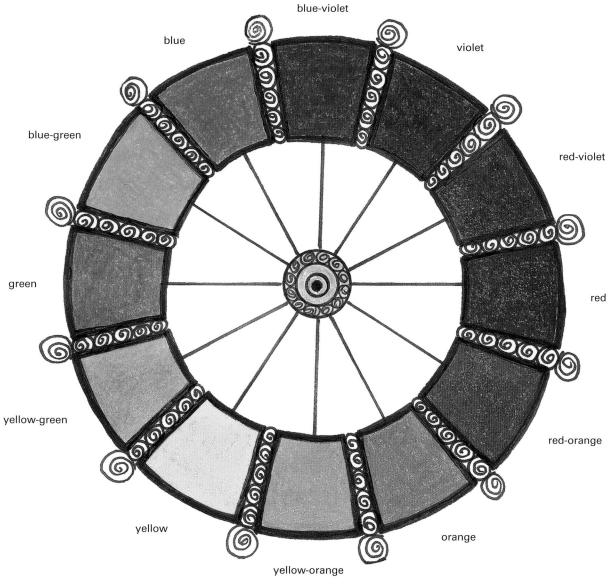

Color Wheel
This is your "go-to" reference tool for determining which colors work best together, in relation to where they fall on the color wheel. In this section we'll take a look at some tried-and-true palettes that work every time.

Monochromatic Colors

Monochromatic color schemes are, by far, the simplest palettes to grasp. The root "mono" means one, so it's easy to remember that the color scheme refers to one color and the lights and darks of that color. To make a monochromatic color palette, choose a color on the wheel and add tints of white and black to it. In order to prevent this palette from becoming too one-note, it is best to pair it with a neutral: white, cream, gray, taupe or black. This will not only provide visual impact, but will create balance and cohesiveness to your piece.

Soothing Designs
There's something very soothing about using one color in design. The various lights and darks create just enough visual interest. It's also a subtle way to decorate and works in any room of the house.

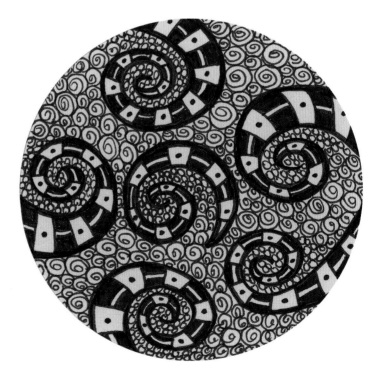

Create Contrast
Yellow creates the most contrast against that black Micron pen. It's the reason that road signs or any other sign meant to get our attention use this color combo. If you want to make the boldest statement possible, use black ink on a yellow background.

Complementary Colors

The next easiest color combination is a complementary scheme. These are two colors directly across from one another on the wheel (think holiday time and school mascots). These colors work well together, and the contrast between them creates quite the wow factor. These color combinations pop!

Split-Complementary Color Scheme

A lesser known, but equally successful palette within this scheme group is the split complementary. To make this palette, pair any color on the wheel with the two colors on either side of its complement. This provides the same exciting contrast, but with more colors.

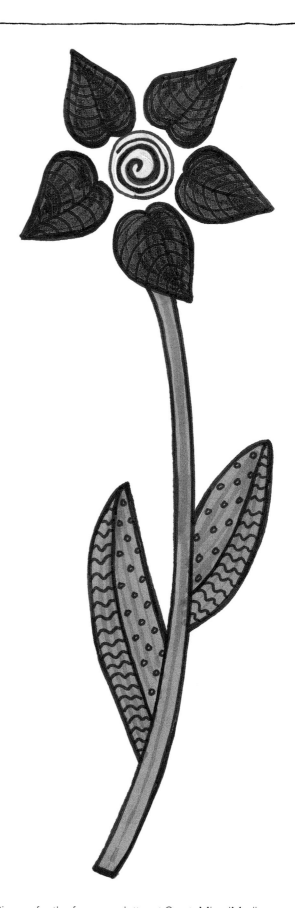

Analogous Colors

The analogous palette allows for combining the most color options. An analogous color scheme consists of three colors that sit next to each other on the wheel. They are grouped together in a way that evokes more of an emotion than visual contrast. Analogous colors are involved when we talk about cool-tone and warm-tone colors.

Combining Color Schemes

For added interest, try combining color schemes. A good example of this can be found in my backyard garden. The majority of my perennials flower in shades of red-violet, violet and blue-violet, leaning more toward a cool-tone palette. I've taken it one step further, by combining this analogous scheme with a complementary one. Adding violet's complementary color (in my case, the yellow-blooming day lilies) gives the garden a visual punch. Adding oranges or yellows to a cool palette or adding blues and violets to warm-tone colors is stunning. The same effect can translate to your Zentangle designs.

Warm Feelings

The warm-tone colors evoke feelings of a setting sun, autumn pumpkins and the arrival of sweater season.

Popular Color Trends

Now let's look at some popular color palettes, along with some of my personal favorite schemes. Try adding color to your tangles, and you'll soon have your own favorite schemes!

Timeless Neutrals

There's been a twist recently in upping the sophistication level on nursery décor: pairing those pastel colors with a neutral. One color combination that keeps popping up is yellow and gray, a timeless combination. By combining a neutral with a color, you wouldn't have to repaint until that infant is well into grade school. I'm sure many adults would love to see that same pairing in a bedroom, bathroom or office space.

Get Your Green On

People everywhere are doing their part to save the planet and embracing the "green movement" by taking the color right into their homes. One reason for green's popularity is its association with nature and everyone's interest in bringing the outdoors in. The color's calming effects make it an easy color to live with. Whatever the reason, green is showing up in almost every room in the house. Why not add it to your tangles?

Dramatic Color Combination

One of my favorite ways to create drama in a room is the play of black and white against spring green. Although it's a brighter shade of green, it still creates a soothing environment in my guest room. Try this color combination in your Zentangle designs.

Cool It

If you asked me, "What's your favorite color?" I wouldn't be able to give you an answer. I like a lot of colors, but greens, blues and purples are my absolute favorites. I think they're all beautiful on their own, or combined together. These colors are in the garden area, kitchen, dichroic jewelry pieces, and fabrics throughout my home. Maybe it's a subconscious need to lower my blood pressure, but the calming effects that these colors provide are an added bonus.

Regal Round-Up

In the late 1980s and early 1990s there was a trend in using regal jewel-toned colors in the home. I never really understood the appeal of forest green, navy blue, and burgundy in home décor fabrics. Instead of buying a jewel-colored bed-in-a-bag ensemble, I headed straight to a clothing store. These are now my favorite colors to wear. Not only do I like them, but they seem to make anyone who wears them look good.

Tropical Punch

This is the ultimate in combining a warm-tone, analogous color scheme with a cool-tone, complementary color. This palette is closely related to a Mediterranean scheme, which I'm convinced will be the colors of my next kitchen. The sunny yellows and oranges against the cool aquas simply spell F-U-N! Why do you think ice cream shops and vacation resorts use these colors throughout? Coincidence? I don't think so.

A Tangled Web We Weave
Mixed media on bristol board
8" × 8" (20cm × 20cm)

Chapter 5
Tangled Projects

Now it's time to take a Zentangle off the tile. Look through this chapter at all the different applications for Zentangle, and be fearless in your own tangled pursuits. Not only can Zentangle stand on its own, but it can be combined with other mediums for some very exciting results. Zentangle adds texture, interest and cohesiveness to a variety of projects.

To ease you into making tangled projects, we'll start with fairly simple applications on paper. From there, we'll move on to tangled artworks, simple 3-D shapes, and then more complicated 3-D objects. As you peruse the projects in this chapter you'll see that I make pretty, practical items for my own use. Try it yourself!

Project Patterns

Most of the designs I used in this chapter's projects are standard Zentangle patterns. See the Project Patterns sidebar in each project to learn which patterns I used, and look them up on TanglePatterns.com or in your favorite Zentangle book.

Helpful Resources

See the Resources section at the end of the book for additional information on products or the colored embellishments used in this chapter's projects.

To start experimenting with color, try subtle applications first: use black ink on a single-colored background. The colored cardstock used for scrapbooking has a similar weight and surface texture of Zentangle tiles and allows the ink to glide evenly. Black pen ink will have the most impact against the pastel shades or the lighter bright colors.

To make your scrapbook pages look really creative and different, try making a continuous design around the edges of the cardstock. You could also choose just two corners of the page and unfurl a Zentangle pattern from each.

Another fun idea is to tangle around your photos after you've applied them to the page. You can incorporate your journaling within the design, following the edges of the photo. If you have a fair amount of writing to do, mask off a square block on your page with a piece of paper or cardstock. Tangle around the edges, lift the mask and write in the blank space left behind. This will really make your journaling "pop" on the page.

For all other dark-colored cardstock, try using a white ink gel pen. (We'll use these pens again in the Picture Frame Mats project in this chapter.) I love the chalkboard-like effect that it gives the cardstock. So, are the white gel pens the archenemy of the black Micron pens? Not at all! Each gives its own exciting and unique outcome, so try them both.

Materials

Surface
- Blue cardstock

Sakura Pigma Micron Pens
- .05, .08 black

Project Patterns

Actual and variations of some patterns used for this project:
- Asian Fans
- Btl Joos
- Corn Rows
- Flying Geese
- King's Crown
- Printemps
- Scallops

Printemps
Draw this Printemps pattern square for practice.

Whimsical, Irregular Shapes →
Notice the irregular shape I used in this full-page design. The free-form, whimsical approach allows the page to take on an almost Dr. Seuss-like effect.

Name Sign

A good project for trying markers is a Zentangled name sign. I drew the design for my daughter's name freehand; but you could certainly enlarge a favorite font, print it, and trace around each of the letters.

While constructing the design, you can choose patterns that reflect the personality of the recipient. The pattern in the letter J resembles the musical instrument that my daughter plays. The hearts in the checkered pattern are a part of her last name, and the shell pattern illustrates her love of the beach. I used her favorite colors in the design. The more personal you can make the name-inspired Zentangles, the more successful it will be.

Make the entire design on white cardstock or bristol board. It will be sturdy enough to cut out and apply to a bedroom door.

Now add color with Tombow markers. These are my personal favorites for adding rich, vibrant color to my designs. Because of their dual-tip versatility and wide range of colors (they even offer a blending pen), it is well worth investing in a few of these markers.

Materials

Surface
- White cardstock

Sakura Pigma Micron Pens
- .08 black

Tombow Dual Brush Pens
- Process Blue (452), Rhodamine Red (725), Willow Green (173)

Other Supplies
- 3½" (9cm) scissors for paper crafting
- Craft knife
- Scissors

Project Patterns

I used my own pattern designs in letters J and E. The designs in the letters N and A are variations of the following patterns:
- Knightsbridge
- Printemps
- Scallops

Knightsbridge
Draw this Knightsbridge pattern square for practice.

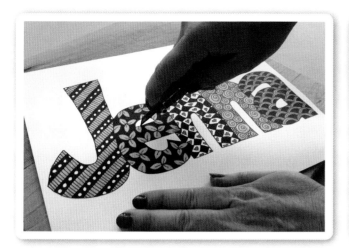

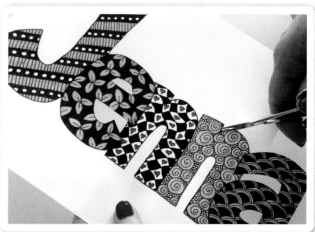

Insides First

Always cut out the inside areas first with a craft knife. This prevents damage and adds strength to the piece.

Outside Edges

Use regular scissors to cut out the remaining outside edges of your name-inspired Zentangle.

Tight Corners

Tiny scissors used for *scherenschnitte* (decorative paper cutting) are extremely useful for cutting into tight corners.

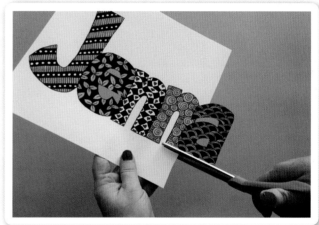

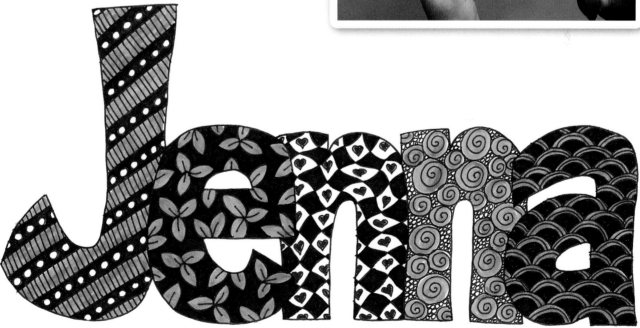

Versatile Technique

In addition to bedroom door décor, try using this technique for greeting cards, gift wrap and scrapbooking.

Artist Trading Cards

Artist trading cards (ATCs) have really gained popularity in the last few years. They're the adult and artist equivalent of baseball trading cards. What an original and fun concept to swap miniature works of art! I've never actually participated in an ATC swap, but I certainly enjoyed making the examples shown.

Because you'll be working on a smaller scale, choose nice filler patterns or ones with borders to go around images or the edge of the card itself. Refrain from using too many small embellishments that will make the design look cluttered.

Materials

Surface
- White cardstock

Sakura Pigma Micron Pens
- .05, .08 black

Tombow Dual Brush Pens
- Rhodamine Red (725), Willow Green (173)

Other Supplies
- Assorted ephemera, collage sheets, stickers
- Deck of playing cards
- No. 2 pencil
- Prismacolor colored pencils

Project Patterns

Actual and variations of some patterns used for this project:
- Corn Rows
- Growth
- King's Crown
- Printemps
- Scallops
- Swirls
- Waves

King's Crown
Draw this King's Crown pattern square for practice.

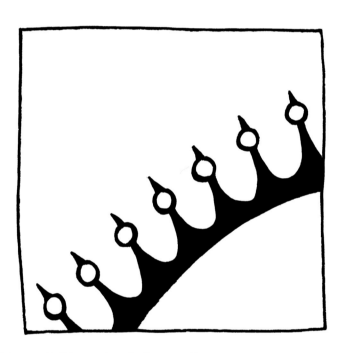

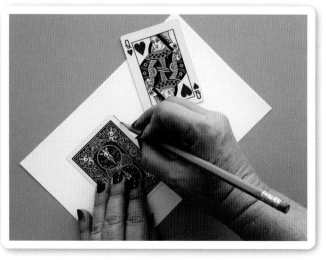

Make Your Own Cards
You can purchase blank cards online, but I traced an actual playing card onto cardstock to make my own. You can round off the corners, like a regular playing card, or leave them square.

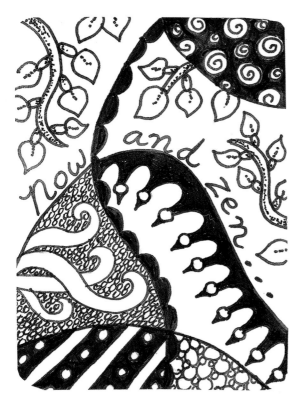

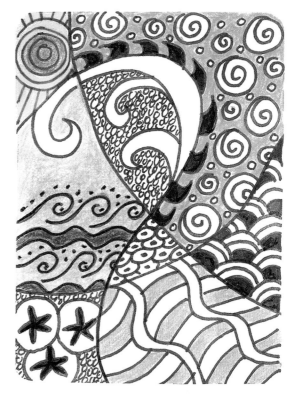

Black and White

Notice the progression of color I used in each card and how it creates varying degrees of impact. The black-and-white card is strong on its own, with its balanced design and use of text.

Muted Colors

I added soft hue colored pencils to the second card. Please note: colored pencils tend to leave a waxy residue. Try coloring your piece last or in-between the ink lines. It's more difficult to draw on top of the colored pencils.

Bold Colors

I made this card with Tombow markers and mixed-media collage sheets. This is a good example of starting with a traditional black-and-white base, and then slowly building up layers of color for the most impact.

School Logo

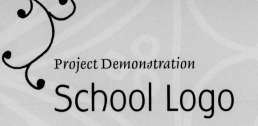

I designed the school logo piece seen here for my daughter's scrapbook. The design celebrates her school letters and colors and could also be matted and framed for her wall. While I was looking at my own sample, I realized how great this pattern would be transferred onto fabric. School logo designs look particularly good on T-shirts, tote bags or enlarged for a pillow.

Fabric Applications

If you are interested in using Zentangle with fabric applications, I encourage you to check out available books covering that topic. There are specific instructions to follow whether you're using markers directly on fabric or creating iron-on transfers.

There is too much information on fabric applications to include here, but I do want to offer some advice on choosing your medium. If you're using Sharpie markers, Sakura pens or fabric markers, you will be somewhat limited by the range of available colors. Your choices may be further limited when looking for markers in various point sizes since not all colors are available in the finer tips. Color limitations aren't always a problem, but sometimes you may need specific colors. In these cases it would be best to use a medium with more color options to create an iron-on transfer. Colored pencils have the largest array of color choices. The next best option is water-based markers. Remember, you'll scan the image on your computer, so the colors do not have to be permanent.

Materials

Surface
- White cardstock

Sakura Pigma Micron Pens
- .05, .08 black

Other Supplies
- No. 2 pencil
- Prismacolor colored pencils

Project Patterns

The center "cross-section" of this project is my own design, created by embellishing swirls and scallops. The four corners are filled using one of my favorite patterns, Pais by Mickee Huber.

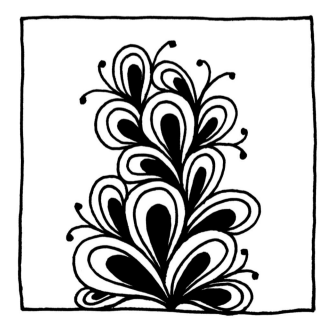

Pais
Draw this Pais pattern square for practice.

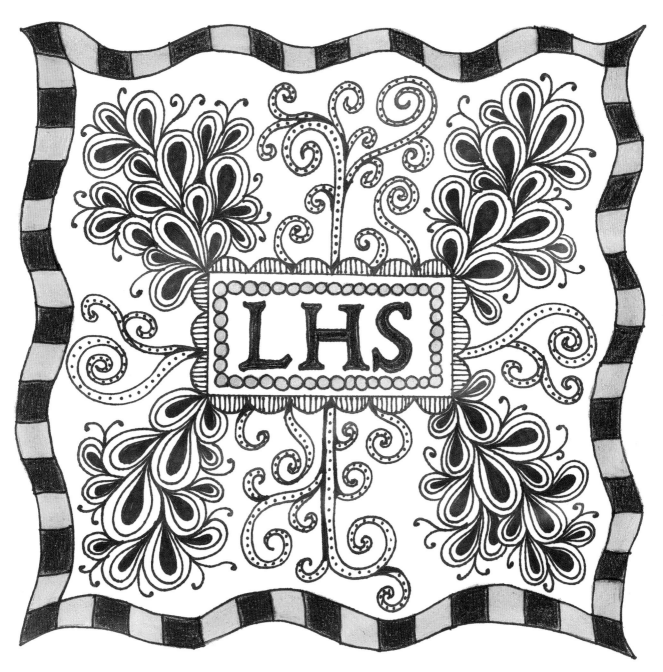

Create an Iron-On Transfer

To turn your Zentangle into an iron-on transfer, scan your drawing, reverse the image, then print on an iron-on transfer sheet. You can find more directions and materials information for this application on the Internet.

Decorative Wrapping

Try making a decorative wrap for a wine bottle or gift tube. The tube size you're using will determine the paper size for your design. For a standard wine bottle holder, create your Zentangle on an 11" × 14" (28cm × 36cm) sheet of paper. This size allows for the paper, lengthwise, to wrap completely around the container. If you're recycling a potato chip canister for use as a gift holder, an 8½" × 11" (22cm × 28cm) sheet of paper will suffice.

Most purchased tubes come decorated, but you can re-cover the container with a simple pattern or solid-colored wrapping paper. Then simply cut your decorative strip and wrap around the center of the tube for a unique, tangled gift holder. If you're ambitious, consider decorating an entire sheet with patterns to cover your canister completely. Keep a sturdy original of your design and print as many copies of your very own wrapping paper as needed for future gifts. Choose your patterns wisely to keep the decorative wrap fun and personal.

Materials

Surface
- 11" × 14" (28cm × 36cm) heavy-weight drawing paper

Sakura Pigma Micron Pens
- .03, .05, .08 black

Other Supplies
- Decorative ribbon (optional)
- Double-sided tape
- No. 2 pencil
- Straightedge
- Wine bottle holder
- Wrapping paper or scrapbook paper

Project Patterns

This entire wrap contains no official Zentangle patterns. By dividing the lines and using simple shapes, I created patterns that showcased my theme of cakes, candles and confetti.

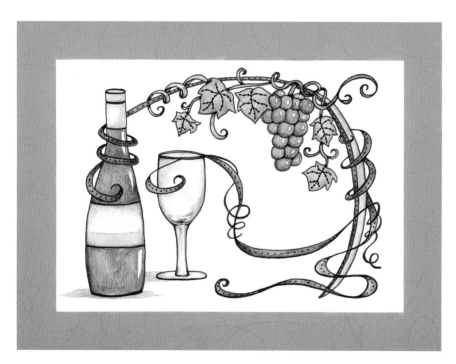

Wine Bottle Wrapping

A bottle of wine is appropriate for just about any gift-giving occasion. Another option would be to keep the pattern on your wrap more general. The recipient could then reuse the holder for another time.

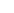

Themed Wrapping

You can see how I "themed out" this bottle holder for a special occasion.

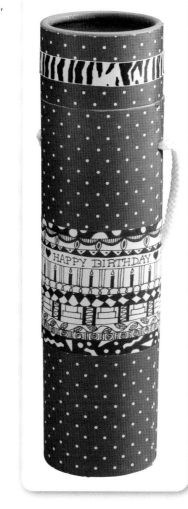

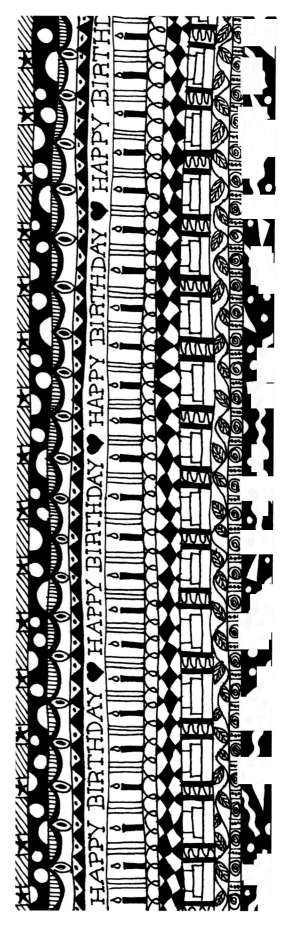

Envelope Liner

What a nice surprise it would be to open a card and discover a uniquely lined envelope. You can buy expensive pattern-lined envelopes, or you can get creative and make your own.

I chose to draw a free-form, all-over pattern with lots of impact. You will need to stretch your design to sufficiently cover an 8½" × 11" (22cm × 28cm) sheet of paper. Consider drawing your design on cardstock, so you'll have a sturdy original and will be able to print as many liners as you want on standard printer paper. Adding color to your design is optional. I like the simple elegance of the black and white on mine.

The template shown will fit most standard-size note cards. Be sure to print the template onto a sturdy piece of cardstock, so you can cut it out and use it repeatedly. Place the template on top of your designed sheet of paper, trace around the edges, and take note of where the dotted lines appear. Trace your template on slightly heavier paper than printer paper for the envelope itself. I used 70-lb. (150gsm) drawing paper. Glue the patterned paper to one side of the envelope. Fold the sides inward along the dotted lines. Use a glue stick along the outermost edges of several areas to hold the envelope in place.

Materials

Surface
- White cardstock

Sakura Pigma Micron Pens
- .05, .08 black

Other Supplies
- 70-lb. (150gsm) Strathmore drawing paper
- Acid-free glue stick
- No. 2 pencil

Project Patterns

The liner is comprised of variations of the Printemps and Jelly Roll patterns, both created by Suzanne McNeill, CZT.

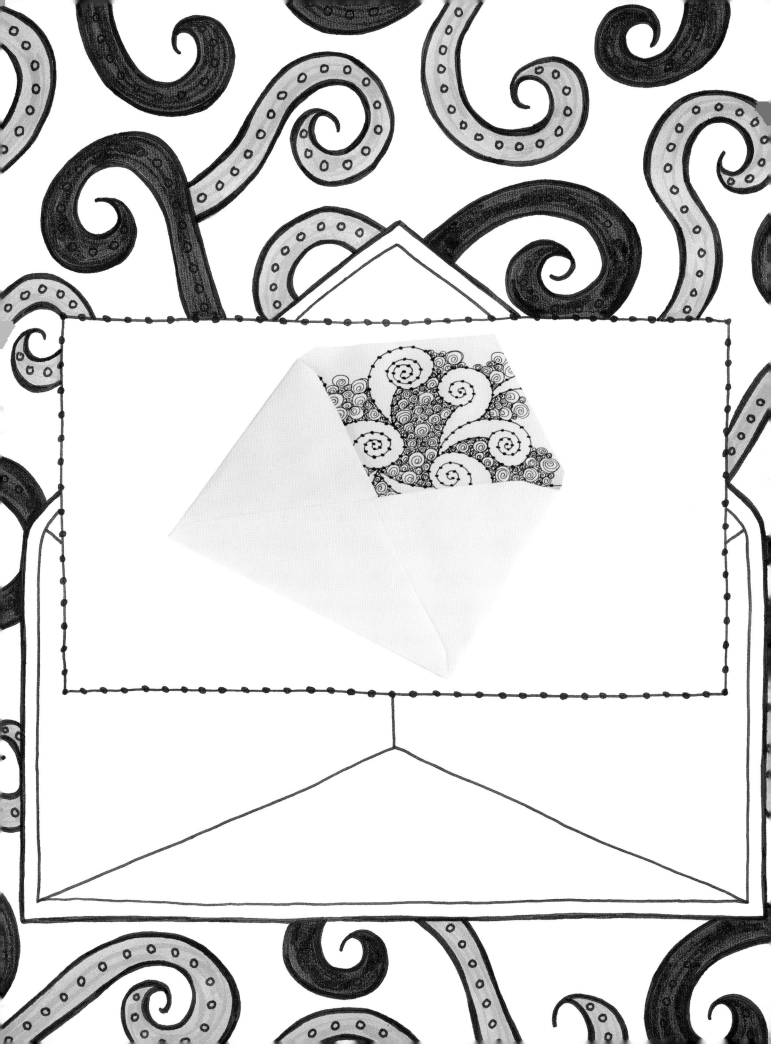

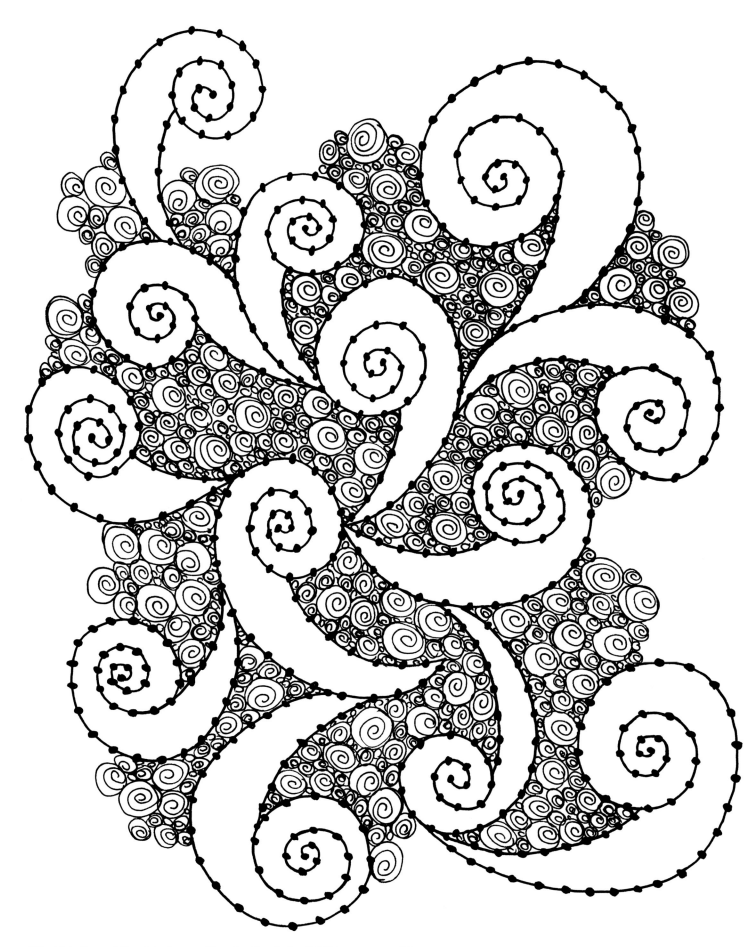

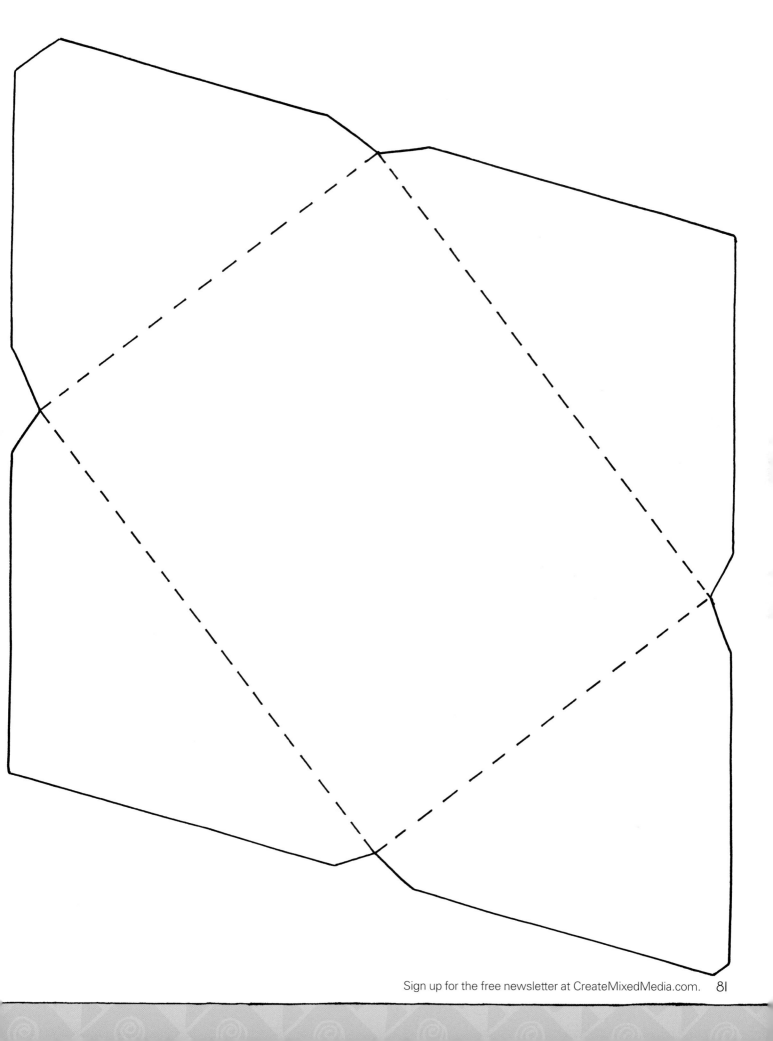

Project Demonstration
Bridal Shower Invitation

The inspiration for this project came as I was waiting at a bridal shop to pick up my daughter's prom dress. The backs of some bridal gowns in the posters lining the store windows captured my attention. I knew the patterns of lace, beadwork and tulle could be made into a Zentangle.

I sketched my image in pencil on the white cardstock, removed the excess lead with an eraser, and finished the design with Micron pens. For those less experienced in illustration, simply trace a figure from a bridal magazine. If your tracing is too large, use a copier at home or at a print shop to reduce it to fit four to a sheet of 8½" × 11" (22cm × 28cm) cardstock.

Follow the same process for the shower information. Cut sheets of 8½" × 11" (22cm × 28cm) colored cardstock in half, and fold for a standard-size party invitation. Trim as needed, and glue or tape the image and the info sheet to the front and inside areas. These will fit inside a standard note card envelope.

Materials

Surface
- White cardstock

Sakura Pigma Micron Pens
- .03, .05 black

Other Supplies
- Colored cardstock
- Double-sided tape
- Kneaded eraser
- No. 2 pencil

Project Patterns
I started this shower invitation with a basic line drawing. Then I added detail with additional circles and dots that alter the basic Btl Joos pattern.

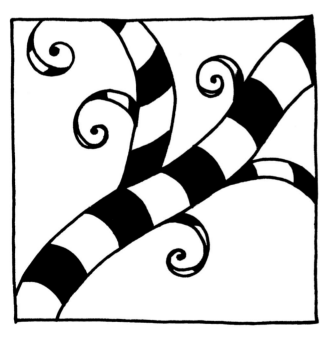

Btl Joos
Draw this Btl Joos pattern square for practice.

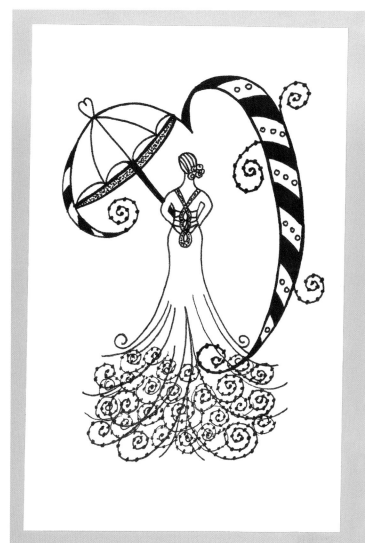

YOU'RE INVITED TO A BRIDAL SHOWER

FOR: _____

DATE: _____

TIME: _____

PLACE: _____

RSVP: _____

Project Demonstration

Wrapping Paper

Zentangle-inspired wrapping paper is a fun way to express yourself and make a special gift. Create your design on an 8½" × 11" (22cm × 28cm) piece of cardstock. Simply sketch your pattern in pencil, filling the entire size of the design area. (Notice that my design is not set up as a repeat pattern.) Remove the excess graphite with a kneaded eraser. Color the design with markers and finish the outlines and detail with black Micron pens.

There are several options for turning your design into wrapping paper. Take your design to a local copy center to have it enlarged. For small packages, enlarge on 11" × 14" (28cm × 36cm) or 16" × 20" (41cm × 51cm) thin, glossy paper. For larger packages, order a blueprint copy or an engineering-size print. This option usually costs around five dollars.

There are also several websites that will print your designs into a roll of wrapping paper for around fifteen dollars. For this option, you'll have to enclose your design in a smaller square. It will then be tiled with other blocks of color as one continuous pattern of wrapping paper. Instead of blocks of color, why not swap them for black-and-white photos tiled with your black-and-white tangle? No matter which route you go, this paper will really make a statement.

Materials

Surface
- White cardstock

Sakura Pigma Micron Pens
- .05, .08 black

Tombow Dual Brush Pens
- Orange (933), Process Blue (452), Rhodamine Red (725)

Other Supplies
- Kneaded eraser
- No. 2 pencil

Project Patterns

This wrapping paper design does not use any established Zentangle patterns. I simply added lines, swirls and circles to the basic circle and paisley shapes.

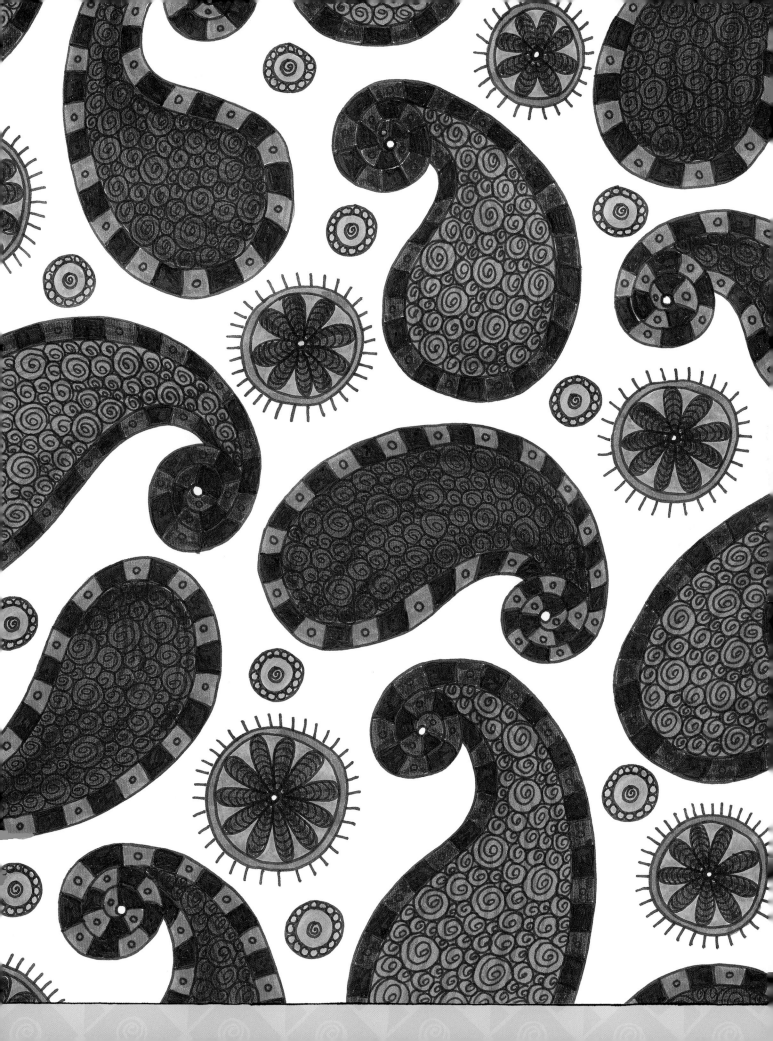

Zendala

Although Zentangle dictates the omission of rulers, templates and other precision drawing tools, a mandala is the one exception. I used a cereal bowl, margarita glass and circle templates to form the basic structure. Add additional design elements by tracing around decorative stencils and templates.

By filling in the mandala shapes with color and pattern, you can turn it into a zendala. I've included two zendalas here for you to color and/or further embellish. (See my colored zendala on the table of contents at the beginning of the book.)

Print your design onto cardstock. Apply color with the markers first, then use black Micron pens to draw a variety of Zentangle patterns. These works of art can be framed or adhered to coasters, trivets and tabletop surfaces.

Materials

Surface
- White cardstock

Sakura Micron Pens
- .03, .05 black

Other Supplies
- Tombow Dual Brush Pens in your choice of colors

Project Patterns

These Zendala designs do not use any set Zentangle patterns. I simply added lines, swirls, circles, hearts and checkerboard patterns to the traced circles.

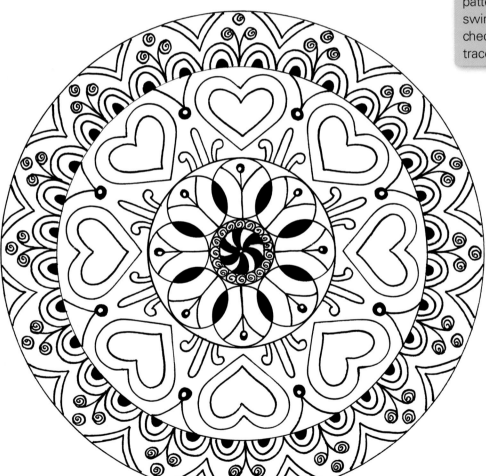

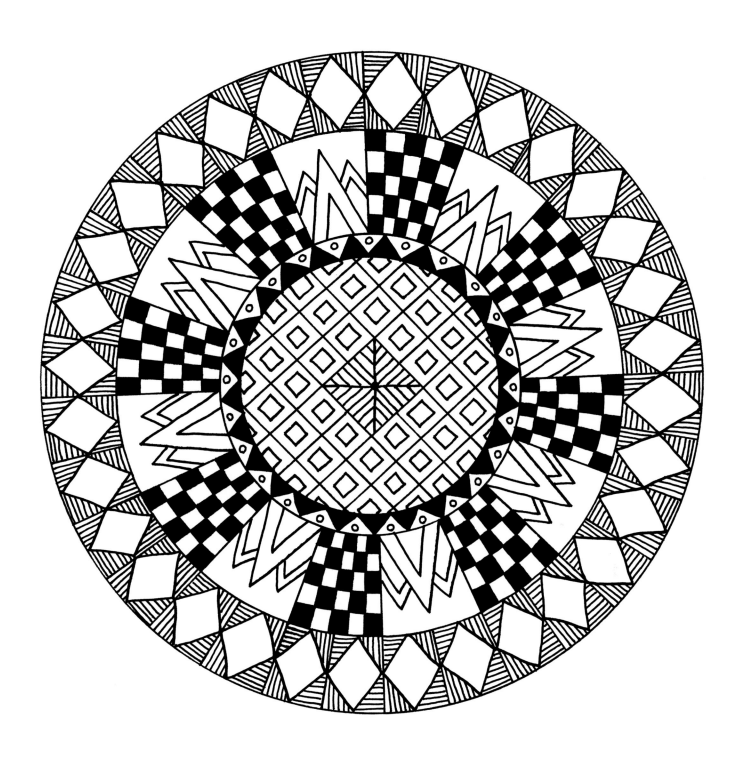

Tangled Masterpiece

This is an example of taking a recognizable object and creating a Zentangle around it. I simply photocopied the face and neck of Leonardo da Vinci's famous painting in black and white, cut around it, and reprinted onto a piece of cardstock. By adding the various patterns, I was able to create clothing, hair, landscape features, and an oval frame to enclose the finished piece. I used a soft pencil to color certain areas gray and to shade others. I rendered the remaining shaded areas with a stippling technique.

Make Your Own

A portrait-type painting is a challenging exercise with Zentangle, even for an intermediate artist. But you can take the same concept, and bring it down a few notches. How about starting with a simple Tuscan landscape or tropical beachfront scene? Print some of the basic elements from the painting and then fill in the trees, sky, land and water with patterns. Before you know it, you'll have your own tangled interpretation of a masterpiece!

Materials

Surface
- White cardstock

Sakura Pigma Micron Pens
- .03, .05, .08 black

Other Supplies
- Prismacolor colored pencils

Project Patterns

To keep this piece true to life, I didn't use any official Zentangle patterns. I achieved realism through lines and circles in the landscape, wavy lines and stippling in the hair and eyelet shapes in the clothing.

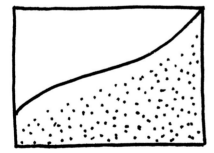
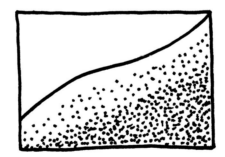
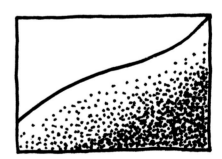

Stippling Technique

Stippling is a unique way to add shading to your Zentangle designs. Apply dots of ink repeatedly to the surface to indicate the gradation of light to dark. For the quickest coverage, use a .05 or .08 Micron pen.

Tangled Mona Lisa →
Colored pencil and pen on cardstock
11" × 8½" (28cm × 22cm)

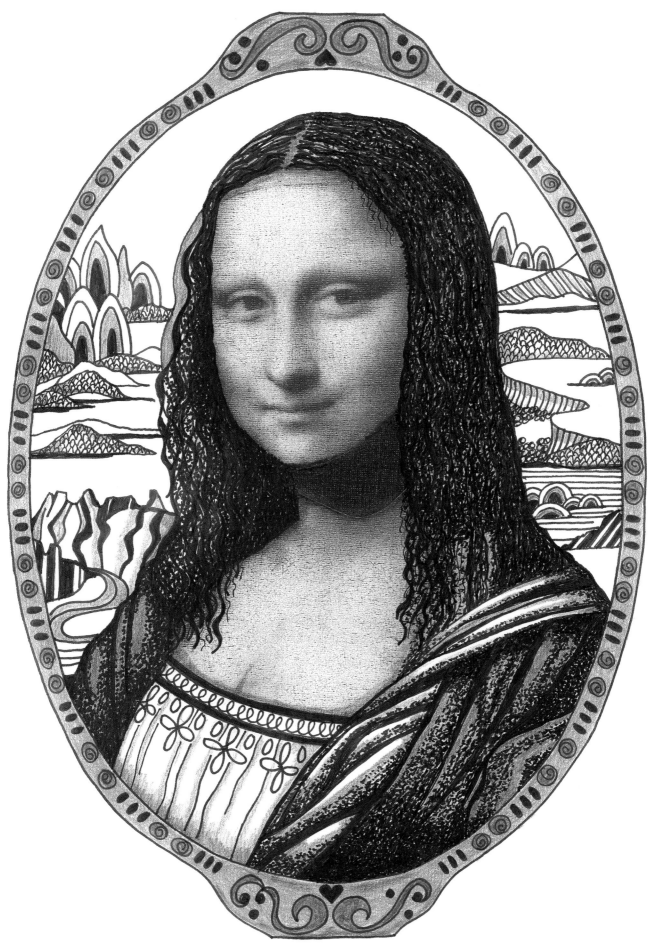

Starry, Tangled Night

Once I tangled the *Mona Lisa*, I began thinking about other Old Master paintings. Maybe I should try a landscape format instead of a portrait. Vincent van Gogh's textured paintings nearly cried out to be tangled! An obvious choice is *Starry Night*. The swirls in the sky and the patterned land below offered endless opportunities.

Along with texture, Van Gogh is known for his use of rich, bold color. I used Tombow markers to achieve the same effect in my design. I replicated some of the colors by layering one marker on top of another.

Materials

Surface
- White cardstock

Sakura Pigma Micron Pens
- .05, .08 black

Tombow Dual Brush Pens
- Dark Olive (158), Orange (933), Process Blue (452), Process Yellow (055), Purple (665), Reflex Blue (493), Sand Brown (992), Sea Blue (373), Willow Green (173)

Other Supplies
- Kneaded eraser
- No. 2 pencil

Project Patterns

I tangled most of the painting with additional swirls, dots, circles and lines. The only official pattern is Pais, which appears in the foreground tree.

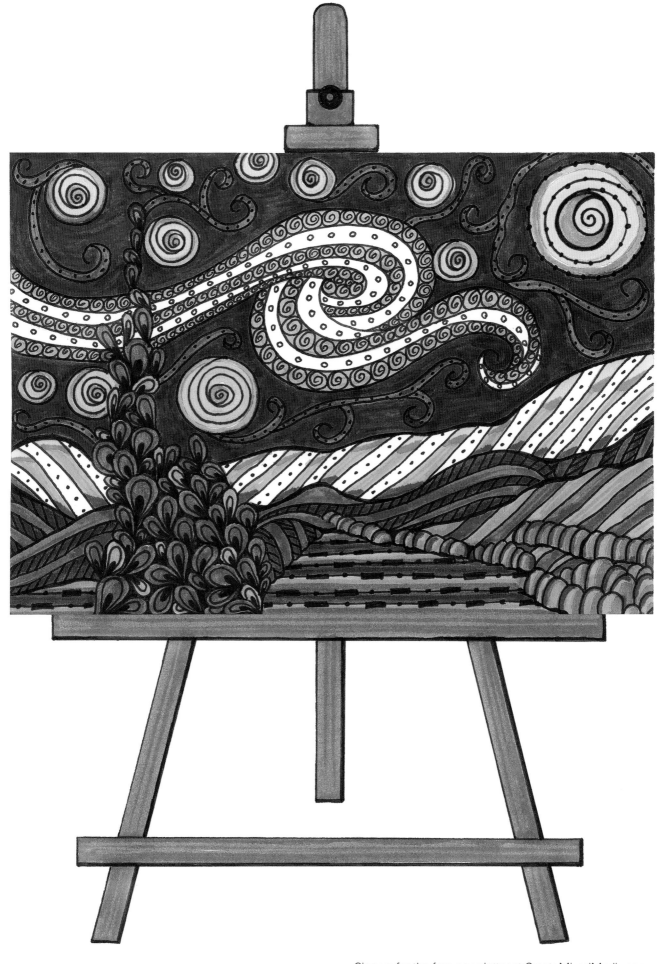

For a more challenging project, consider tangling a favorite animal or your own pet. I recommend making the basic outline of the body and eyes look true to life. You can then be more spontaneous with pattern selection for the rest of the portrait.

Start by enlarging the photo and tracing the outline of the pet's head, eyes and nose. I used watercolor pencils and colored pencils to bring the drawing to life and stay true to the colors in the photo. I used white acrylic paint to lighten areas of the fur and for the eye highlights.

Choose patterns that are similar in size and shape to the markings or that emphasize them when filled in. If your pet is a solid color, with few markings, color the basic features the same way, then finish by filling in with a small pattern that allows for many black-inked areas for darker fur, or leave it open for light fur.

Cut scrapbook paper to 11" × 8½" (28cm × 22cm). Turn the paper over and measure a 1-inch (25mm) border on all sides. Use a ruler and no. 2 pencil to connect markings and form the inner rectangle. Cut out the opening with a craft knife. Attach the mat to the front of the artwork with tape.

Materials

Surface
- Cold-pressed illustration board

Sakura Pigma Micron Pens
- .03, .05 black

Other Supplies
- Craft knife (optional)
- Derwent Inktense watercolor pencils
- Double-sided tape
- No. 2 pencil
- Prismacolor colored pencils
- Ruler
- Scrapbook paper
- Small brush
- White acrylic paint

Project Patterns
I kept tangling to a minimum, achieving a more realistic appearance through simple curved lines and swirls.

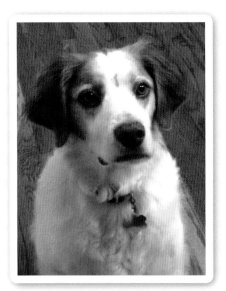

Riley
This is my Brittany spaniel, Riley. If you look closely, you'll see numerous spots and other unusually-shaped markings on her face. This makes it easier to create a more realistic portrait peeking through the Zentangle patterns.

Anticipation →
Mixed media on cold-pressed illustration board
11" × 8½" (28cm × 22cm)

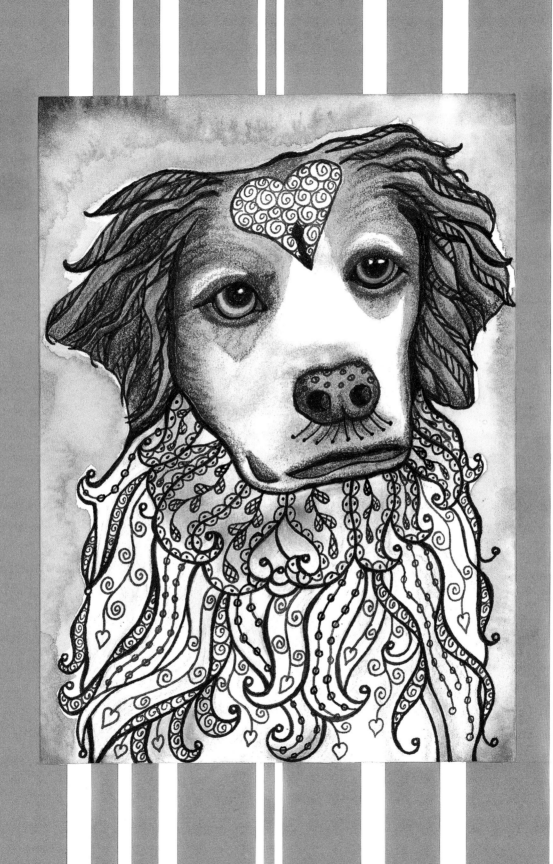

Tangled Rain Forest

Try using Zentangle to highlight specific textural areas within an illustration. Mask off the design area on the watercolor paper with painter's tape. Pencil in the basic outlines of the animals, plants and trees. Lightly rub over the surface with a kneaded eraser to remove excess graphite. Randomly color the design with watercolor pencils in several shades of green. Dip the brush in water and start spreading the watercolor across the design area, leaving some areas white.

After the piece is thoroughly dry, remove the painter's tape. Finish the drawing with Micron pens, choosing specific areas to apply patterns and stippling. Place the piece facedown on a clean surface and stack heavy books on top to smooth the watercolor paper (leave for at least 12 hours). Mount your finished design on illustration board with double-sided tape.

Materials

Surface

- 140-lb. (300gsm) cold-pressed watercolor paper

Sakura Pigma Micron Pens

- .03, .05 black

Other Supplies

- Derwent Inktense Watercolor pencils in shades of green
- Double-sided tape
- Illustration board
- Kneaded eraser
- Painter's tape
- No. 2 pencil
- No. 10 round watercolor brush

Project Patterns

This is another example of not using set patterns. Rather, I brought this jungle scene alive through added lines, scallop shapes and stippling. (See the Tangled Masterpiece project for more info on stippling.)

Jungle Watch →
Watercolor pencil and pen on cold-pressed watercolor paper
10" × 6½" (25cm × 17cm)

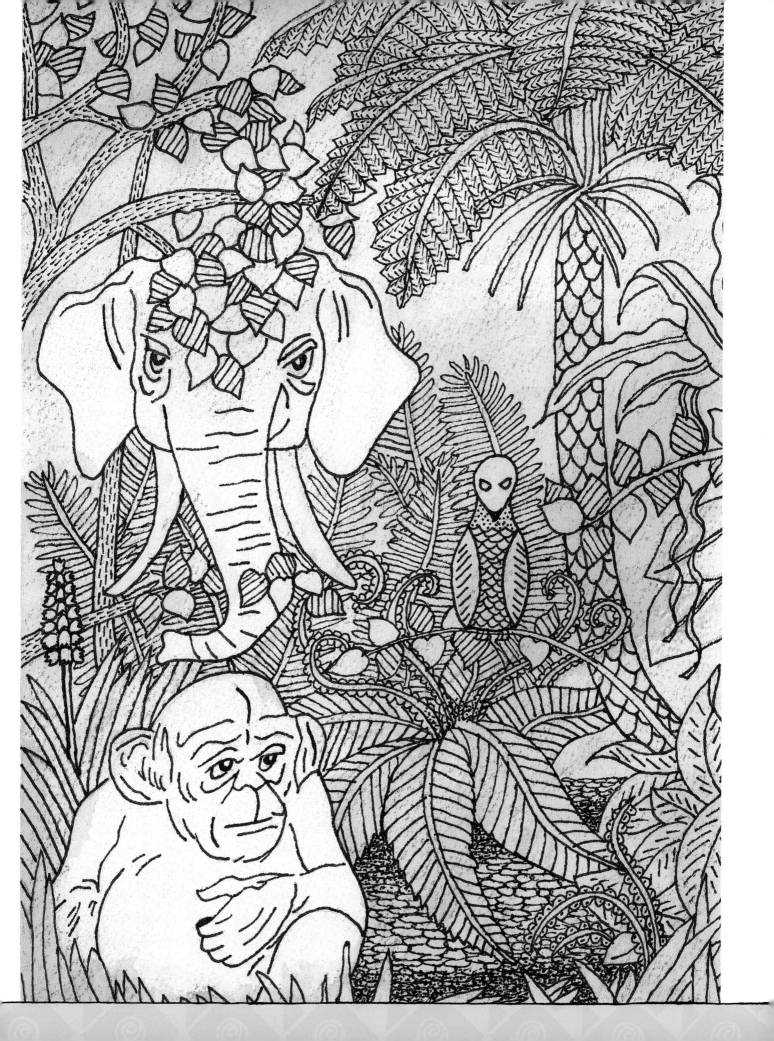

Zentangle jewelry is economical to make and results in some outstanding pieces to sell or give as gifts. Try drawing a large-format design to reduce for a smaller application. Reducing the design (rather than trying to create a tiny design) results in a more detailed and elegant piece. Also, the reduced pattern will make minor imperfections in the drawing less noticeable.

Heart Pendant
I ordered both the glass tile and pewter pendant online (see Resources section). The heart pendant was an odd shape to enlarge. I could have traced it and then enlarged my tracing by 50 percent, but I felt comfortable enough with the dimensions to draw a pattern at actual size.

Rectangle Pendant
The rectangle shape of the glass tile is easier to enlarge. I doubled the actual size of the tile to 2" × 4" (5cm × 10cm) on cardstock, drew the design, and took it to a print shop to reduce it by 50 percent. Scanning patterns into your own computer will allow you to manipulate the design and print multiples of the same print on a single sheet of cardstock. Be sure to use a laser printer since an ink-jet printer will smear the design. Print on cardstock so you'll have something more substantial to work with when adhering it to the back of the tile.

Materials

Surface
- White cardstock

Sakura Pigma Micron Pens
- .05, .08 black

Other Supplies
- E-6000 adhesive
- Glass tile
- Pewter heart-shaped bezel
- No. 2 pencil
- Sakura 3D Crystal Lacquer
- Satin cord or chain
- Silver jewelry bail
- Small scissors

Project Patterns
Actual and variations of some patterns used in these two pendant designs:
- Hollibaugh
- Printemps
- Queen's Crown
- Scallops

Hollibaugh
Draw this Hollibaugh pattern square for practice.

Rectangle Pendant

Apply a thin coat of crystal lacquer to the glass tile, then place the cut design, pattern-side down, against the glue on the tile (the tile shows through the glass). Trim the edges of the cardstock. Let dry thoroughly, then add an additional coat of the lacquer to the back of the pendant to seal it. Crystal lacquer is a strong enough adhesive to use when attaching a silver jewelry bail to the tile. For an even stronger alternative, use E-6000 adhesive. Once the bail is attached and thoroughly dry, complete the necklace with whatever chain you like.

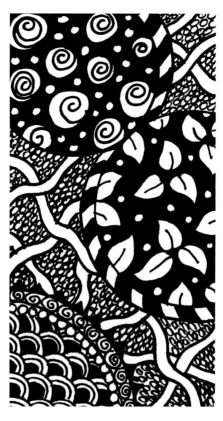

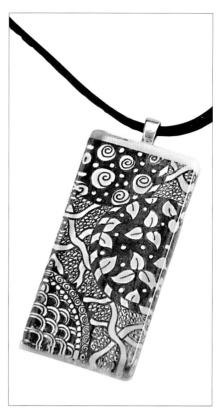

Heart Pendant

Trace the shape on cardstock, draw a design with a Micron pen and cut the piece to fit inside the pendant. Use crystal lacquer to adhere it to the inside and fill the remaining cavity of the pendant. Let it dry overnight. Finish the piece with a black satin cord.

Picture Frame Mats

These mats work wonderfully inside actual picture frames, but they can also decorate scrapbook layouts or be used as refrigerator magnets. You can purchase plain black or white mats online through many craft, scrapbooking and rubber stamp companies. If you prefer to start from scratch, use a craft knife to cut your own mats. For oval or circular openings, make the window cut first, then cut the exterior edges of the mat. This increases stability and makes the frame less likely to tear.

I found that symmetrical, border-type patterns looked best on mats with square openings, and random, all-over patterns work best for circular openings. Be sure to try the white gel pen on the black cardstock for a totally different effect.

Materials

Surface
- Black or white photo frames or cardstock

Sakura Pigma Micron pens
- .05, .08 black

Other Supplies
- Craft knife
- Ruler
- White Sakura Gelly Roll pen

Project Patterns

Actual and variations of some patterns used in the mat with the oval opening:
- Droplets
- Emilie
- Marquee
- Matt
- Printemps
- Scallops

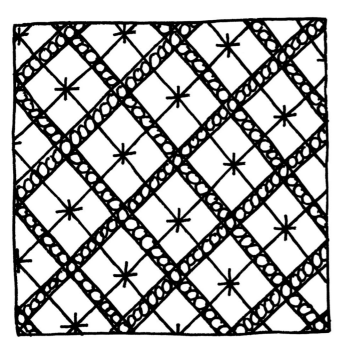

Marquee
Draw this Marquee pattern square for practice.

Frame Edges and Corners

Try choosing border-type patterns for photo frame edges, and single, repetitive images to place in the corners. This gives the frames a symmetrical and more finished look.

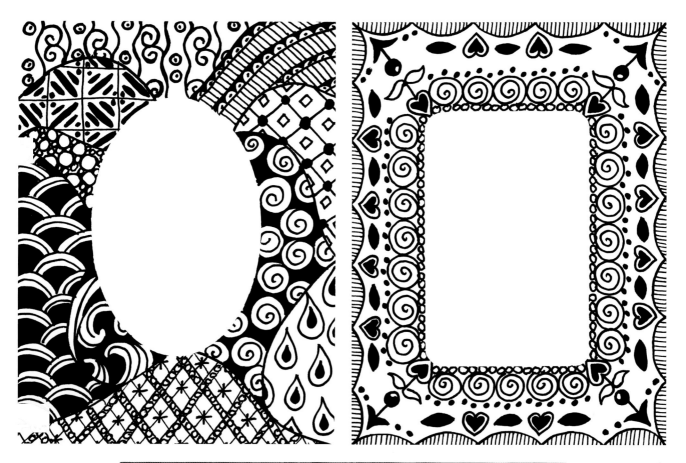

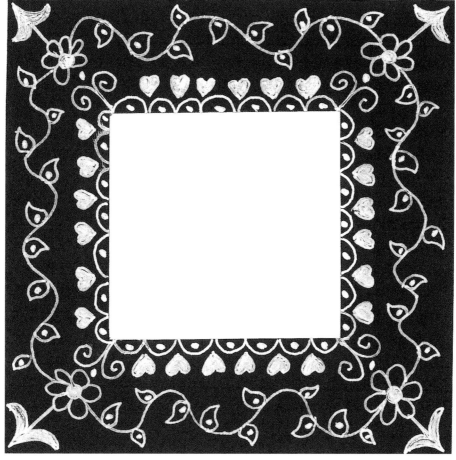

I based the pattern for this set of coasters on a deck of playing cards. Consider using a border pattern, similar to the Picture Frame Mats project, then cut an opening for a 1" (25mm) square photo insert. I bought these coasters at a local craft store, but you can find other comparable sets online.

Begin by removing the paper insert from each glass coaster. Use the insert as a template to trace onto the cardstock. In keeping with the card theme, I used red and black Micron pens. After completing the patterns, simply slide the cardstock inserts back into the coasters. You could further customize the set by basing your design around a center monogram. What a wonderful gift idea!

Materials

Surface
- White cardstock

Sakura Pigma Micron Pens
- .05, .08 black
- .05, .08 red

Other Supplies
- No. 2 pencil
- Photo coasters set
- Scissors or craft knife

Project Patterns
I made all four designs for this project by embellishing open diamond shapes. The inner squares are comprised of scallops and swirls drawn in a symmetrical pattern.

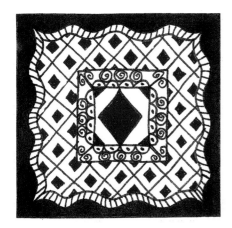
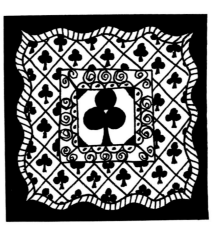
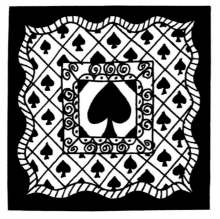

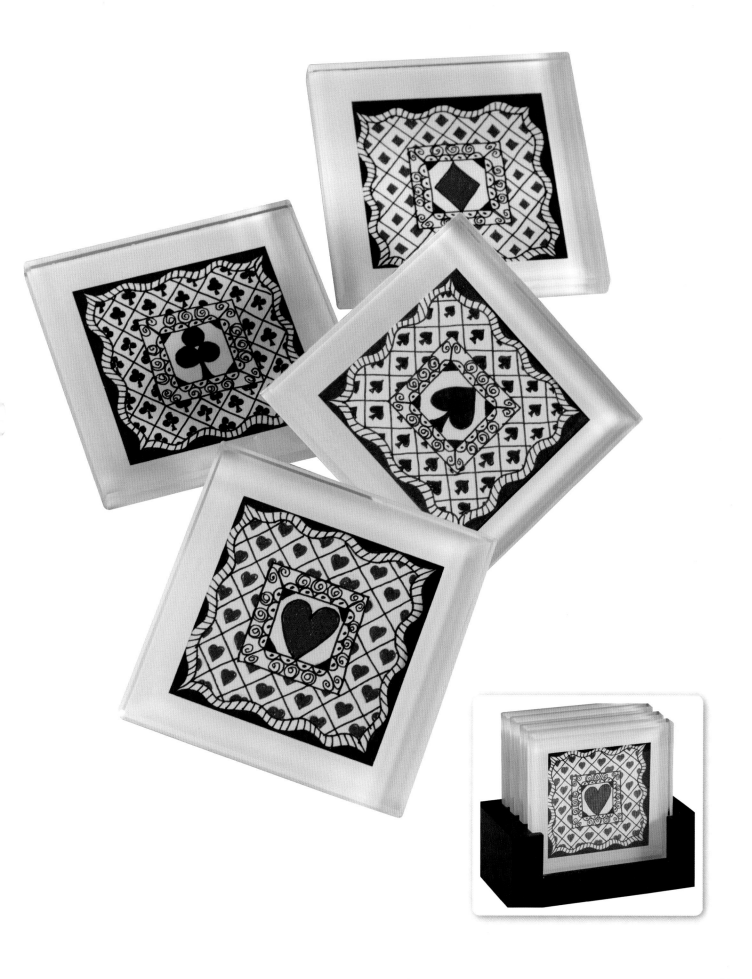

Collaged Notebook

An artist sketchbook or journal is a blank canvas to showcase an array of creative techniques. There's no need to disassemble the front cover from the spiral binding. Instead, mount the finished piece directly onto the cover.

Cut a piece of watercolor paper to fit the front cover. Next, brush on vertical streaks of watercolors, blending together with water to fill the entire sheet. After it's thoroughly dry, stamp on images with different colors of ink. I used black ink for the flower stamps I intended to tangle. Go over the stamped ink image with a Micron pen to ensure a cohesive black shade. Using the same pen, embellish the upper corners with another Zentangle pattern. Apply ephemera, printed text and ribbon with Mod Podge. Finish with a final coat of Mod Podge over everything and attach the sheet to the book cover using the same sealant.

Materials

Surface
- 140-lb. (300gsm) cold-pressed watercolor paper

Sakura Pigma Micron Pens
- .05, .08 black

Other Supplies
- Assorted paper scraps/ephemera
- Decorative stamps
- Grosgrain ribbon
- Mod Podge, matte finish
- No. 12 round watercolor brush
- Permanent ink pads, various colors
- Scissors
- Spiral-bound, hardcover journal
- Watercolor paints

Project Patterns

This mixed-media cover contains stamped images that I further enhanced with swirls, lines and borders. I used the Pais pattern and a variation on the Tendrils pattern to line the edges.

Don't Smear It!

If you include any printed text or designs, use a laser printer. Mod Podge will smear ink-jet printed images.

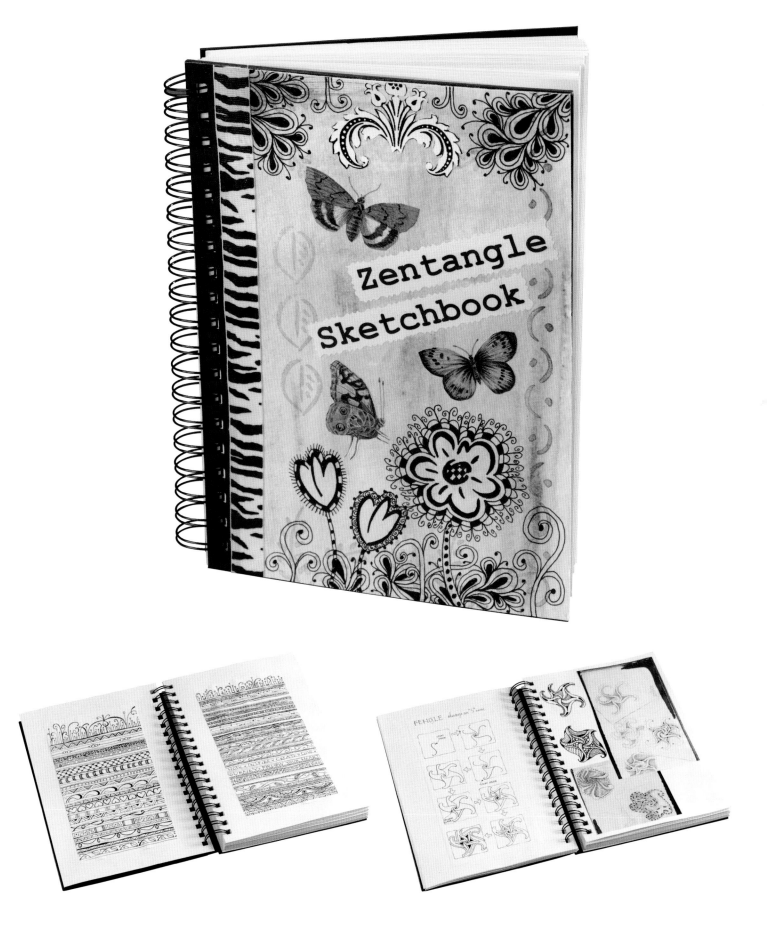

Owl Magnet

This is a simple project that even kids will enjoy making. For inspiration, I found an owl template online. Clip art and coloring books are also good choices for finding basic shapes that can be filled with patterns.

Start by penciling the major sections of the owl and the basic Zentangle pattern onto the cardstock. Remove the excess graphite with a kneaded eraser. Use markers to add color. Outline and finish the patterns with Micron pens.

Cut out the owl shape and trace it onto the cardboard. Use a craft knife to cut the mirror image out of the cardboard. Adhere the cardstock piece to the cardboard with tape.

Outline various features and the entire owl body with a Sharpie. Finish by applying the magnetic strips to the back. Depending on the size of your piece, you may need to use additional hot glue or E-6000 adhesive to secure the strips to the back.

Materials

Surface
- White cardstock

Sakura Pigma Micron Pens
- .05, .08 black

Tombow Dual Brush Pens
- Orange (933), Process Blue (452), Process Yellow (055), Purple (665), Willow Green (173)

Other Supplies
- E-6000 adhesive or hot glue
- Craft knife
- Double-sided tape
- Fine-point black Sharpie
- Kneaded eraser
- Magnet strips
- No. 2 pencil
- Scissors
- Sturdy cardboard

Project Patterns

The design on this magnet gets its detail from swirls, lines and stars that I added to a variety of open-space patterns.

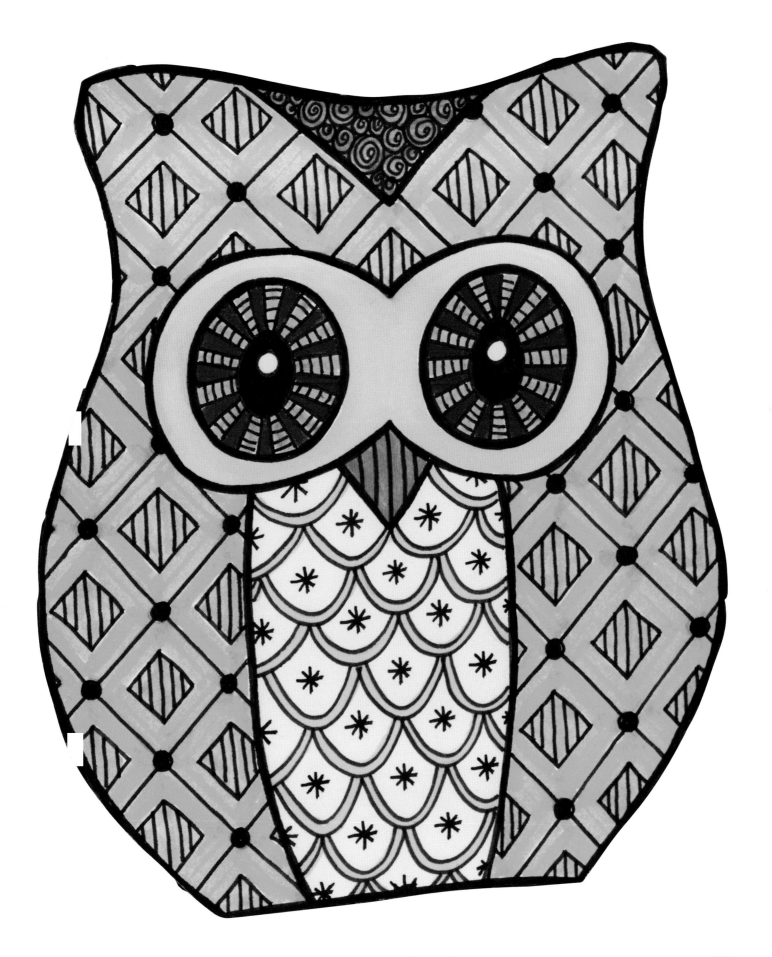

This project is for a keychain, but you could use the same process to create jewelry. Condition the clay and roll out to ¹⁄₈" (3mm) thick. Press a Shapelet (polymer clay template) into the clay, cut out the form and pierce a hole a ¼" (6mm) from the top. Bake the clay according to the package directions and let cool. Lightly sand the top surface.

Draw patterns with Micron pens and let the ink dry thoroughly. Heat set the ink and allow it to set overnight. Dab, rather than brush, sealer over the top to avoid any additional smearing on heavily-inked areas. Let dry. Brush the sides and back with two coats of acrylic paint. Apply another coat of sealer to the painted areas. Bend the wire to form a triangle, slide it through the hole and close it with pliers. Attach a key ring to the wire piece.

Materials

Surface
- Sculpey III Polymer Clay

Sakura Pigma Micron Pens
- .01, .03 black

Other Supplies
- ¼-inch (6mm) flat brush
- 1½" (38mm) piece of fine-grit sandpaper
- 18-gauge wire
- Black acrylic craft paint
- Heat gun
- Jewelry pliers
- Key ring
- Polymer clay sealer
- Premo! Sculpey Shapelets, Classic Design Shapes
- Sculpey clay cutting, rolling and piercing tools

Project Patterns
For the keychain design, divide the space into five sections, and add swirls, lines, curves, hearts and stars.

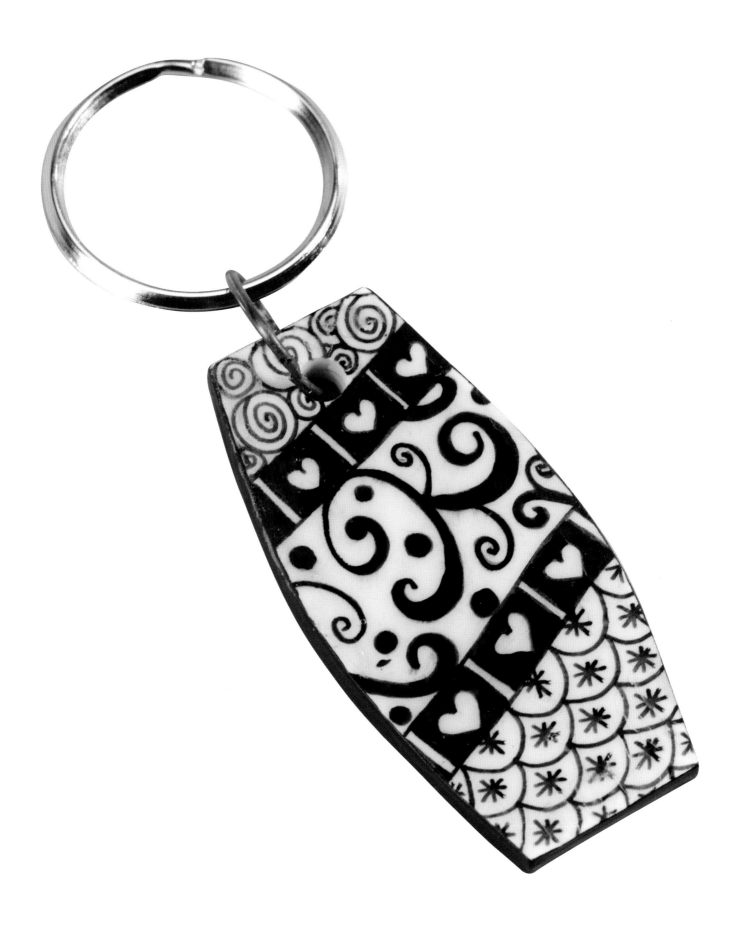

Mandala Paperweight

Creating a "Zendala," or Zentangle-designed mandala, is a good way to literally think outside the box since it means moving on from the basic square shape you are accustomed to. Creating designs with circular shapes opens up new possibilities for translating Zentangle patterns.

There are a couple ways you can handle circular designs. The first is to use a circle template (found at most art supply stores) to lightly draw consecutive circles in varying degrees of size within the largest circle shape. For this type of mandala, place border-type patterns around each circle. This gives a balance and order to the design, but leaves room for endless combinations.

Another approach to circular designs would be to treat the circle as you would a square Zentangle. Draw the strings and fill in each area with a different pattern.

These are probably not the type of Zentangle you would draw while waiting in the doctor's office since you would generally start a Zendala by tracing a perfect circle. (I certainly don't carry a circle template around in my purse.) However, if you want to draw imperfect circles to fill in with patterns while waiting for the bus, have at it!

To demonstrate this technique, I made a beautiful and practical project for use in my studio at home: a color wheel paperweight. I designed it with colored pencils and a Micron pen. Most Zendalas are drawn in a more whimsical, free-form style than this, but I wanted to create a "perfect color wheel," so I used a protractor and straightedge to make the design balanced and precise.

Materials

Surface
- White cardstock

Sakura Pigma Micron Pens
- .05 black

Other Supplies
- Black cardstock
- Circle templates
- Glass paperweight
- Mod Podge, matte finish
- No. 2 pencil
- Prismacolor colored pencils
- Protractor
- Straightedge

Project Patterns

This paperweight is a good example of pure design vs. tangling with patterns. I used a protractor and straightedge for precise measurements and the design elements are realistic or symbolic.

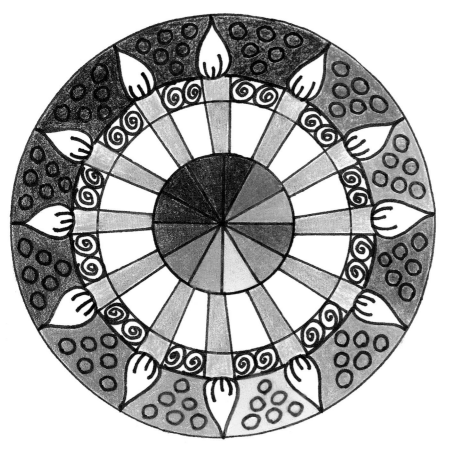

Circular Design Possibilities

I turned this design into a paperweight, but it could also be enlarged, matted, framed and hung on the wall as a lovely art piece for the room. The circular shape allows for many creative possibilities in home décor. Think about using your designs on coasters or table tops, or tangling around a circular mirror. You could also expand into the area of ceramic paint markers and try your hand at decorative plates, serving pieces and trivets. You could create some wonderful Zendalas for your kitchen with patterns from your dishware.

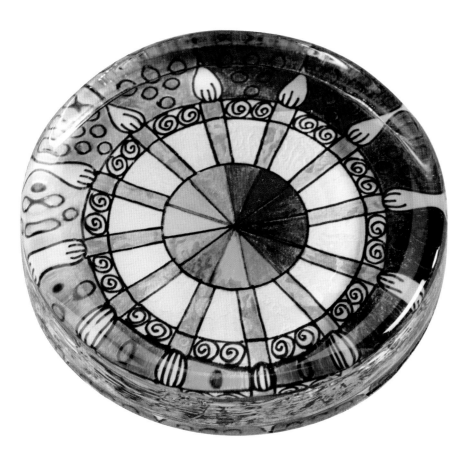

Whimsical Design

I didn't want my design to look too mechanical, so I added paint brushes to divide the different colored sections. The small circles within those sections represent bottles of paint, and I added the swirls just for fun. Apply a thin coat of Mod Podge to the back of the paperweight. Press your design face down onto the Mod Podge and let dry thoroughly. Trace and cut a circle of black cardstock and glue it to the back of the paperweight. Finish with a final coat of Mod Podge.

Wine Glass

Painting on glass isn't new in the craft world, but adding a Zentangle design to it certainly is. Choose a simpler pattern since you won't be able to get the same level of detail with the materials for this particular application. The nibs on glass paint markers and bottles are quite a bit larger than fine-tipped Micron pens. The benefit of simpler designs is that they can be free-flowing, spontaneous and graphic. The resulting whimsical effect may also enable you to hide some painting mistakes.

Make sure your glass is clean, dry and smudge-free. I used the Vitrea 160-series of paint markers from Pébéo. I found the markers to be easier to control when applying the paint. If you have a steady hand, you may want to try the bottles with the applicator tips.

Remember to keep your shapes simple and on the larger side. Think swirls, wavy lines and dots. I used a variety of these concepts. Note: The stem of the glass was the most difficult part to paint. I suggest either applying dots or swirling paint randomly on the entire length of the stem. It is nearly impossible to draw a straight line around the glass. Allow the painted glass to thoroughly dry for 24 hours. You may then bake it in the oven for 40 minutes at 325° F (163° C) to set the paint and make it permanent.

Materials

Surface
- Wine glass

Other Supplies
- Pébéo Vitrea 160-series glass paint markers

Project Patterns

This project's surface and medium doesn't allow for repetitive patterns. The surface becomes an explosion of hearts, swirls, dots, scallops and doodle shapes rather than detail work.

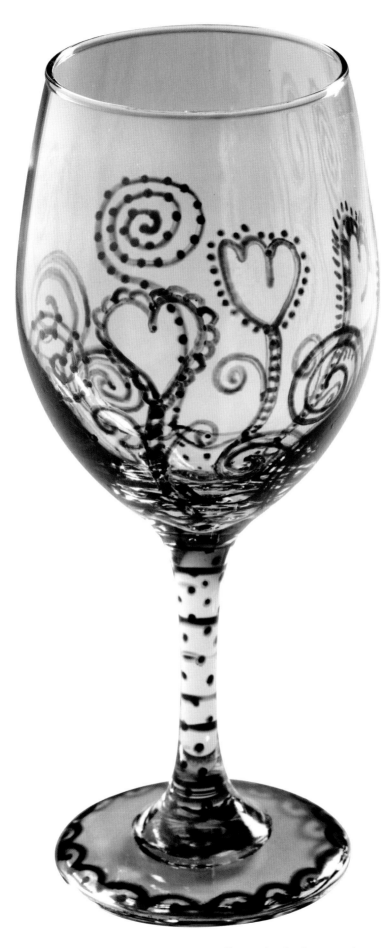

Children's Shoes

Create this project with an inexpensive pair of toddler shoes. Make sure you choose a smooth leather surface, as opposed to canvas. The Micron pens glide across the surface better and produce a sharper image.

I made the pair of shoes match each other, with the same patterns on the same area of each shoe. Small, filler designs look nice on the Velcro strap, and larger images fit well on the top or along the sides. Use a water-based ink pad for stamped images, then go over them with a Micron pen. After you've drawn all the images on both shoes, let dry overnight. To set the Micron pen ink, place the shoes in a clothes dryer with a couple of old towels and let them go through a normal heat cycle.

Materials

Surface
- Leather shoes

Sakura Pigma Micron Pens
- .03, .05, .08 black

Other Supplies
- Black water-based ink pad
- Stamps

Project Patterns

Most of the patterns on these shoes are my own designs with hearts, scallops and dots. However, the Pais pattern and a variation of Scallops make an appearance.

Scallops
Draw this Scallops pattern square for practice.

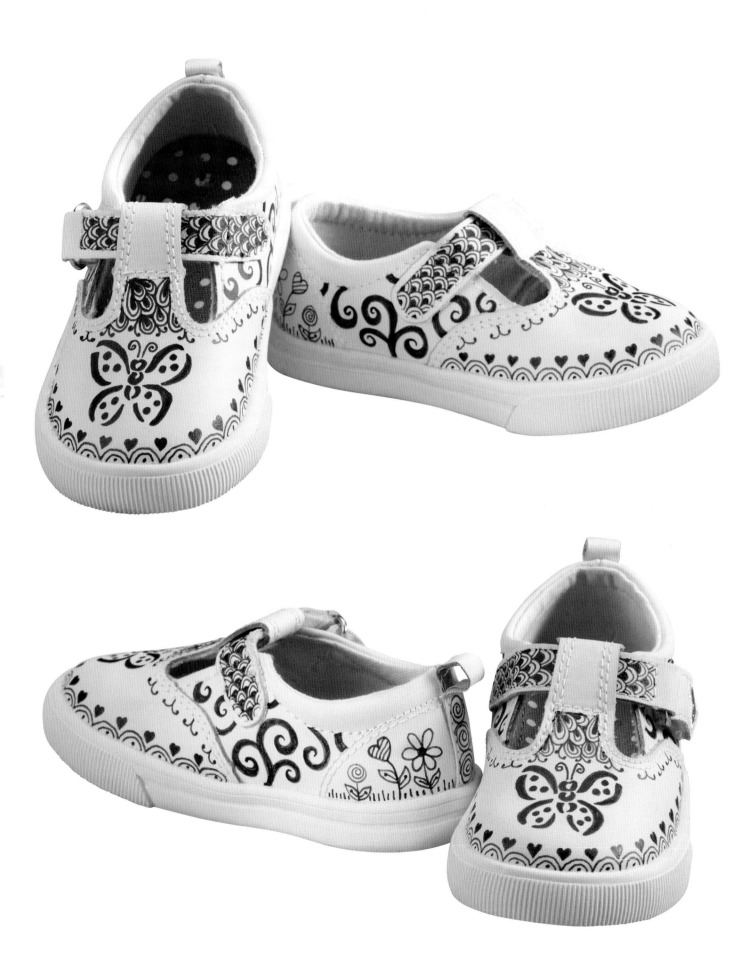

Your approach to tangling on fabric depends on the type of project you're creating. If you're making something that will be going through the washing machine, you need to use fabric markers. This project will not be washed, so I used a Sharpie instead. Sharpies produce a darker black than fabric markers.

Stretch half of the fabric around the cardboard and secure with tape. Trace the template on the fabric with pencil. Complete the design with Sharpie markers, then cut it out, and heat set the fabric with an iron. (You'll draw patterns only on this one piece, as the other will become the plain, underside of the crab.) Trace the template on the other fabric half and cut out the second shape.

With the right sides together, sew around pieces, leaving an opening on the bottom for turning right-side out. Stuff the crab with fiberfill (a small paintbrush handle is useful for filling tight areas) and hand stitch the opening at the bottom closed. Attach the two black beads for the eyes with hot glue.

Materials

Surface
- ¼ yard (23cm) blue cotton quilter's fabric

Other Supplies
- 8" × 10" (20cm × 25cm) cardboard
- Black beads
- Blue thread
- Crab template
- Duct tape
- Hot glue gun with glue sticks
- Needle
- No. 2 pencil
- Poly fiberfill
- Sewing machine (optional)
- Ultra-fine-point black Sharpie

Project Patterns

I used variations on the Tendrils and Scallops patterns and lots of simple swirls on this fabric crab.

Tendrils
Draw this Tendrils pattern square for practice.

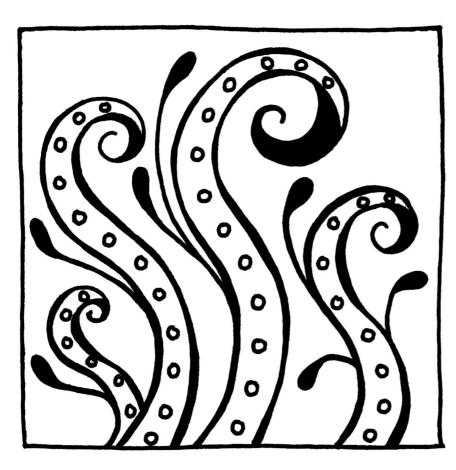

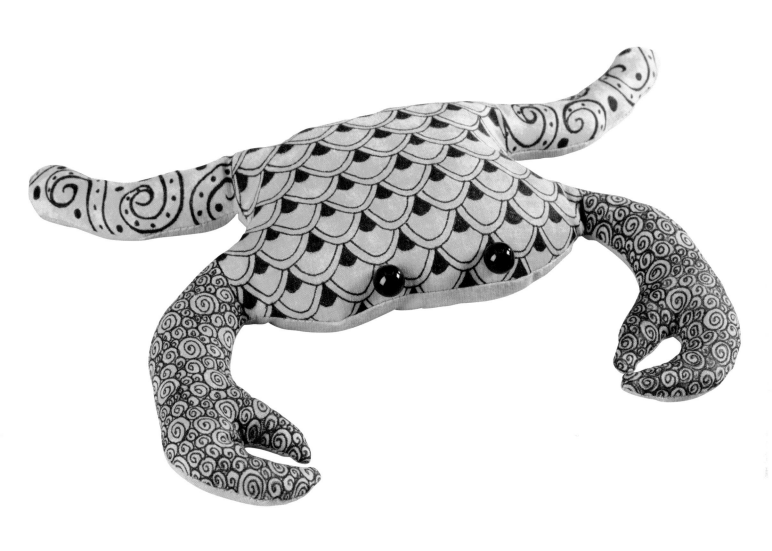

Terra-Cotta Pots

I made two different pots: one for indoor and one for outdoor use. I would suggest using the outdoor one in a covered area to protect it from the elements.

Outdoor Pot

Starting with the plain terra-cotta pot, draw the patterns in pencil and remove the excess graphite with a kneaded eraser. I used a combination of the paint marker and the Micron pen to finish the design. Terra-cotta is porous and will soak up the ink well. Finish with two coats of Mod Podge to seal it.

Indoor Pot

Prime the top and the inside of a glazed pot with Kilz, then paint with two coats of white acrylic paint. Pencil in the patterns and erase until just faint lines show. Use black Micron pens over the pencil lines and let dry thoroughly. Set the ink with a heat gun. Please note: the heat-set ink may still smear if you try to apply a sealer. I recommend leaving it unsealed. My pot will house an artificial plant, so it will work fine indoors.

Materials

Surface
- Regular and partially-glazed 4" (10cm) terra-cotta pots

Sakura Pigma Micron Pens
- .05, .08 black
- .05 blue

Other Supplies
- Blue Sharpie Oil-Based Paint Marker
- Heat gun
- Kilz primer
- Kneaded eraser
- Mod Podge, matte finish
- No. 2 pencil
- White acrylic paint

Project Patterns

Several pattern variations appear on these terra-cotta pots:
- Btl Joos
- Knightsbridge
- Pais
- Queen's Crown

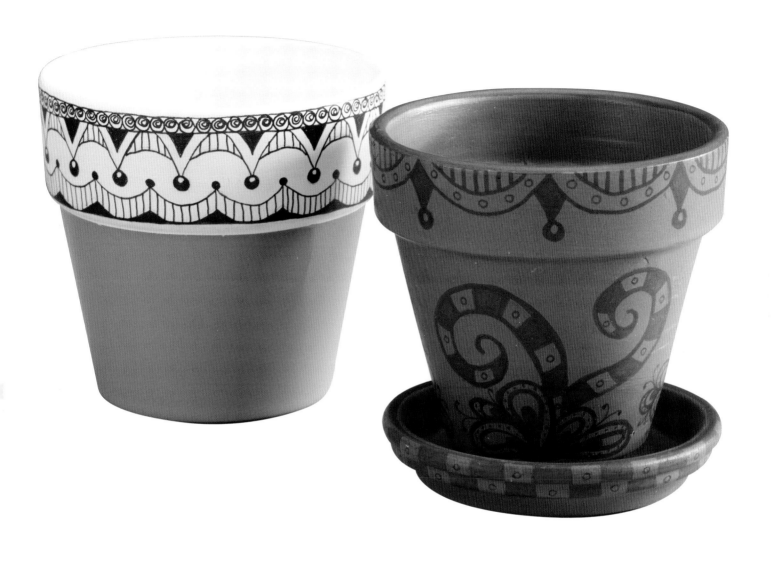

Templates

The following templates are for your own personal use to further embellish with color and Zentangle patterns. Get creative and tangle some templates!

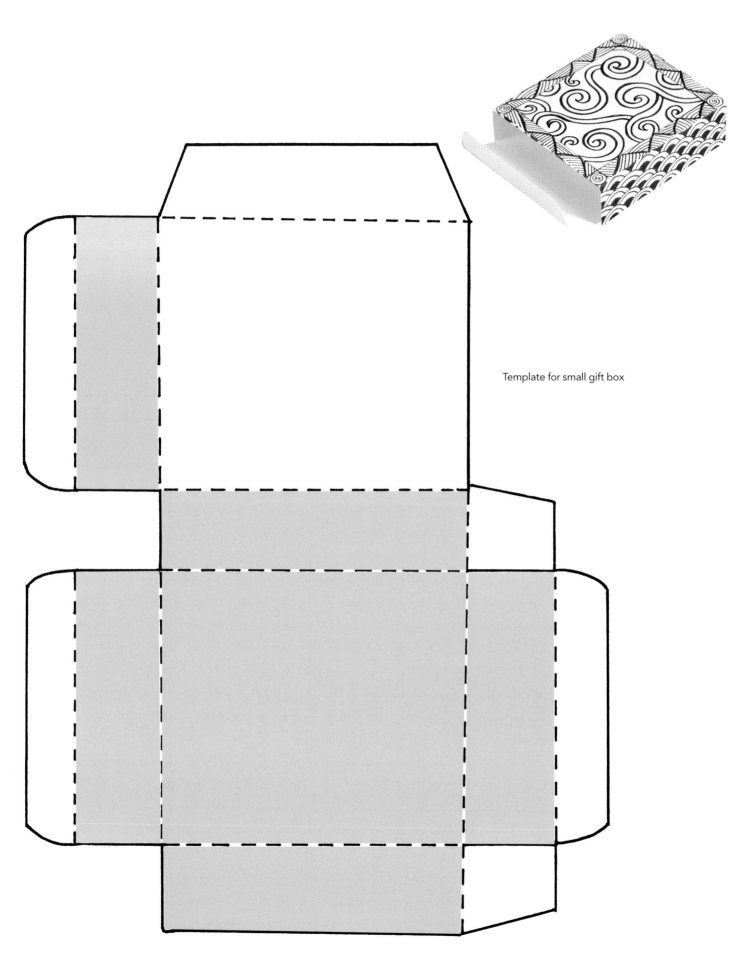

Template for small gift box

A Final Thought

I hope that the pages of this book have been a source of inspiration. Zentangle is what you make of it. Once you master the basics, it's strictly up to you how far and what direction you take it. The limitless applications for this art form are what attracted me in the first place. As an artist, I was drawn to creating my own patterns. The end result was the production of this book.

You may want to take what you've learned in this book, combine it with additional inspiration from other books, and start creating your own designs. If you create artwork with truly original patterns, you can sell your items on Etsy without having to obtain written permission to do so. If teaching is your passion, consider taking the course to become a CZT. If you simply want to enjoy Zentangle as a relaxing hobby, that's OK too! Whatever you decide, each path will give back its own rewards ten-fold.

It's time to grab a pen and begin the first step of your artistic journey. Be confident, creative, inspired and, most importantly, enjoy the ride!

THE ZEND

Resources

People, Books and Websites

Rick Roberts and Maria Thomas: Zentangle.com

Suzanne McNeill: d-originals.com

Sandy Steen Bartholomew: sandysteenbartholomew.com

Linda Farmer: TanglePatterns.com

Marie Browning: *Time to Tangle With Colors*
mariebrowning.com

Betty Edwards: *Drawing on the Right Side of the Brain*

Madonna Gauding: *One Million Mandalas*

Materials

Most basic art supplies, pens and markers can be found online or at your favorite local art or craft store. Here are some resources for more unusual materials:

Collage sheets (piddix.com)
Jewelry supplies (paperwishes.com, craftsuppliesforless.com)
Photo coasters (Michaels)
Glass paperweight (photoweights.com)
Wine glass and wine bottle holder (Old Time Pottery)
Healthtex leather children's shoes (Walmart)
Rubber stamps (Stampin' Up!)
Terra-cotta pots (Home Depot)

About Zentangle®:

The name "Zentangle" is a registered trademark of Zentangle Inc.

The red square logo, the terms "Anything is possible one stroke at a time", "Zentomology" and "Certified Zentangle Teacher (CZT)" are registered trademarks of Zentangle Inc.

It is essential that before writing, blogging or creating Zentangle Inspired Art for publication or sale that you refer to the legal page of the Zentangle website, zentangle.com.

Index

About the Author

Trish Reinhart is a mixed-media artist with a side interest in all things Zentangle. After obtaining her degree in commercial art from Saint Francis University in Indiana, she needed to supplement freelance projects with a "real" job, which proved to be a real unfulfilling experience. Two decades later, she is returning to her first love: art. Trish is currently working on her artisan business, "Reinstonz" and resides in Marietta, Georgia, with her husband, daughter, and their Brittany spaniel.

Photo by Kim Craig Ali

 Other fine North Light Books are available from your favorite bookstore, art supply store or online supplier. Visit our website at fwmedia.com.

18 17 16 15 14 5 4 3 2 1

DISTRIBUTED IN CANADA BY FRASER DIRECT
100 Armstrong Avenue
Georgetown, ON, Canada L7G 5S4
Tel: (905) 877-4411

DISTRIBUTED IN THE U.K. AND EUROPE
BY F&W MEDIA INTERNATIONAL LTD
Brunel House, Forde Close, Newton Abbot, TQ12 4PU, UK
Tel: (+44) 1626 323200, Fax: (+44) 1626 323319
Email: enquiries@fwmedia.com

DISTRIBUTED IN AUSTRALIA BY CAPRICORN LINK
P.O. Box 704, S. Windsor NSW, 2756 Australia
Tel: (02) 4560-1600; Fax: (02) 4577 5288
Email: books@capricornlink.com.au

ISBN 13: 978-1-4403-3515-0

Edited by Mary Burzlaff Bostic
Cover designed by Bethany Rainbolt
Interior designed by Laura Spencer
Materials and project photography by Kris Kandler
Production coordinated by Jennifer Bass

Zentangle®

zentangle.com

The Zentangle method is a way of creating beautiful images from structured patterns. It is fun and relaxing. Almost anyone can use it to create beautiful images. Founded by Rick Roberts and Maria Thomas, the Zentangle method helps increase focus and creativity, provides artistic satisfaction along with an increased sense of personal well-being and is enjoyed all over this world across a wide range of skills, interests and ages. For more information, please visit our website.

Metric Conversion Chart

To convert	to	multiply by
Inches	Centimeters	2.54
Centimeters	Inches	0.4
Feet	Centimeters	30.5
Centimeters	Feet	0.03
Yards	Meters	0.9
Meters	Yards	1.1

Acknowledgments

Special thanks to my editor, Mary Bostic, for taking a chance on a technically-challenged, first-time author. Your expertise made this wild ride much less bumpy, and your patience was appreciated more than you'll ever know!

Dedication

To my husband, Kevin, who helps me believe all things are possible.

To my daughter, Jenna, for being an endless source of inspiration.

To my family and friends, for your love and encouragement.

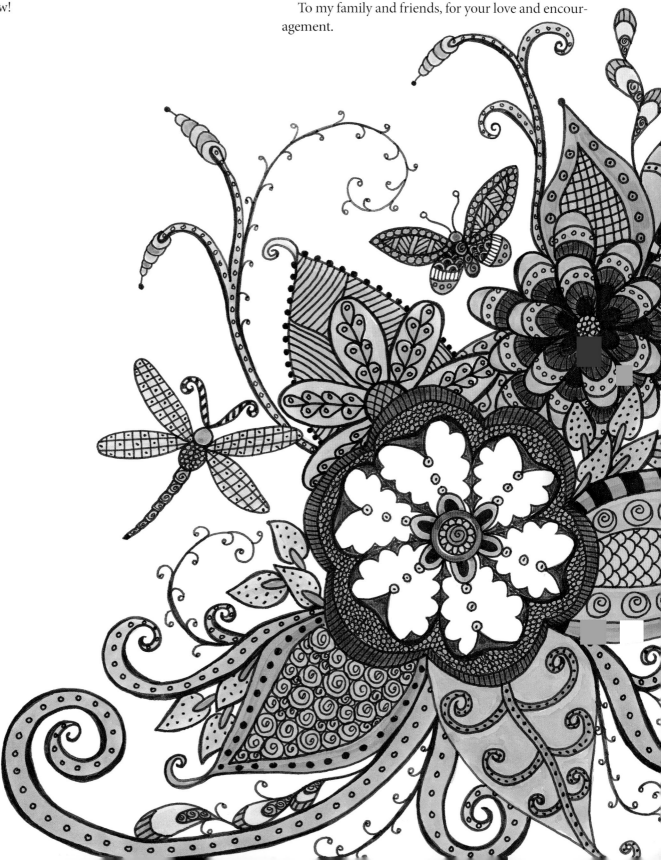